STILL

THOMAS STRUTH

STILL

THE MONACELLI PRESS

GUY TOSATTO | HRIPSIMÉ VISSER | RÉGIS DURAND | *Foreword*

Thomas Struth is considered one of the major figures of German photography. He combines a rigorous style with a neutral, objective vision of reality and an impressively precise technique. Exploring his themes in successive series, he spent several years focusing on the urban architecture of Europe and the United States. Ironing out the exceptional, his gaze concentrated on rows of banal buildings, on vistas of streets without qualities, on the details of anonymous facades. And yet, behind these seemingly blank descriptions of common cityscapes, there lies a profound and serious meditation on recent Western history, and in particular on the traumas caused by the last world war and the architectural "responses" that these elicited.

In the mid-1980s, Struth widened his field of investigation, beginning work on several series of portraits of individuals or groups, particularly families. Here, human emotion is distinctly present but never indulged. It emerges in the psychological density of a gaze, in the singularity of a posture, or, even more conspicuously, in the knotty relationships of the family portraits.

In recent years, Struth has embarked on new themes such as landscape and flowers. These form a gently lyrical counterpoint to the earlier series. He has also developed a fascinating exploration of the places where works of art are shown—both traditional settings such as churches and palaces, and the specialist institutions that are museums—as well as into the modern rituals that shape the public's behavior toward these places and the works they contain. Alternatively sympathetic and ironic, Struth conducts an extremely subtle analysis of the position of the work of art in our society, of our relation to history and heritage and, lastly, of the mysterious and enduring power of art over human beings (a phenomenon which, paradoxically, photography, of all art forms, seems the best equipped to reveal).

This book marks the first major European exhibition dedicated to Thomas Struth. We hope that this event will increase familiarity with his body of work and thus help provide a

clearer definition of what we consider an exemplary artistic enterprise in relation to the field of contemporary photography. It is a pleasure to thank all the lenders for their precious support and, of course, the artist himself, whose unfailing helpfulness and care did so much to ensure the success of this project.

CONTENTS

THOMAS STRUTH | *Acknowledgments*

Many people supported, inspired, and helped me in various ways in creating the pictures presented in this book. Dr. Dieter Schwarz and Dr. Heinrich Huber in Wintherthur, Ma Jiang-Bao in Shanghai, Monica de Cardenas in Venice and Milan, Hannah Erdrich-Hartmann in China, Japan, and Italy, Keiko Shimada in Japan, Lou Yong-Jin in Beijing, Gu Yimei in Shanghai, Ingo Hartmann in China, Janice Guy in Rome, Marian Goodman in Venice, and Susanne Ghez in Chicago. My sincere thanks to all of them. I am also indebted to Guy Tosatto, Hripsimé Visser, Régis Durand, and James Lingwood for their enthusiastic commitment to both the exhibition and the publication.

GUY TOSATTO | *The Time of Photography*

Does not the ubiquitousness of photography in our everyday environment to some extent distort our relationship to it? The question is worth asking in a world where everything can be photographed and by anyone, and where, consequently, the status of the photographic image appears to be increasingly ambivalent: it is both a precious testimony to what is (or what was), and a vehicle for insignificant messages, both an experience tied to the intimacy of private life and a document disseminated globally by the millions. Indeed, the medium has been so weakened by the overdose of images, technical brinkmanship, and the banalization of certain figures of style, particularly in the worlds of advertising and fashion, that we nowadays have real difficulty envisaging photography in artistic terms.

It was, it would seem, in reaction to this phenomenon of the general "devaluation" and loss of meaning of photography, that Thomas Struth began his researches in the mid-1970s. Approaching the medium with an absolute rigor that he had inherited from the teaching of Gerhard Richter and Bernd and Hilla Becher, he returned to the so-called objective gaze, one which, at the very least, comes across as uncluttered by excessive subjectivism and the affectation of a recurring pictorialism. Manifestly, his work is neither forced nor emphatic, and whatever virtuosity it displays is no more than the perfect match between a direct and masterly approach to the medium and a sensitive and ample vision of reality.

This refusal to indulge in the spectacular is also expressed in the artist's favorite themes. Far from facile anecdote or aestheticism, Thomas Struth has, for more than twenty years now, dedicated himself to recording the urban landscapes of the New World, which were born with photography, and those of the Old World, haunted by the ghosts of history. The portraits, the church and museum interiors, the flowers and the landscapes, all constitute supplementary developments around concerns that, over the years, have gained in precision and can now be grouped under the following notions: photography as an extraordinary means of making time, as a privileged medium for clothing memory, as a magical process for banishing death.

STREETS

Rows of banal buildings, prospects of streets without qualities, anonymous facades—these are the characteristics that first strike us when we discover Thomas Struth's images of streets. Usually in black-and-white, they present a frontal, eye-height view, with no optical distortion to disrupt the impression that this is a neutral, objective recording of reality. A reality seemingly so banal that the way we look at these photographs is primarily a questioning one: Why these common buildings, these dull streets, these insignificant views? The question immediately gives way to an insistent melancholy, the melancholy associated with these familiar places whose strangeness and solitude are suddenly brought to light. "This is where men live," the author seems to be telling us. This here, this chosen and designated place, suddenly takes on the weight of history, the history that has shaped our environment over the last few centuries, has determined the structure of our towns, has contributed to the appearance of our streets. The history that has, by the same token, influenced our lives, our parents' lives, and the lives of those before them. And so, in this austere and dispassionate meditation on towns, we find an inquiry into time, a time that only photography seems capable of revealing. That is the paradox of this medium, its ability to fix the impalpable instant while matchlessly capturing the sense of duration.

The landscapes photographed by Struth at the beginning of the 1990s play a subtle counterpoint to the images of streets. If the latter refer to history, to the traumatic events that can be read into the texture of the urban fabric, to its vicissitudes and its inherent temporality, then the landscapes evoke the immemorial: permanence, timelessness. Again, there is nothing out of the ordinary, just simple fragments of domesticated nature offered as an inexhaustible source of calm and consolation. The artist uses color to render the infinite chromatic range of the vegetation and earth in a soft, limpid light. And, in what comes across as the felicitous side of our world—felicitous, perhaps, because free of history's

oppressive silences, those that are felt in the photographs of towns—there is no romantic élan, no transcendence, simply a landscape on a human scale where man seems to have found his proper place, to be finally reconciled with his original environment.

PORTRAITS

What is the source of this intensity, of this emotion we feel in front of Struth's portraits? What is it that speaks to us in these images of unknown faces whose only common feature is the way their gazes all focus on the lens? Behind the lens is the eye of the artist, which, by a trick of photography, becomes our own gaze. There, perhaps, lies the beginning of an answer to our questions. Might not the emotion created by these portraits come from this meeting of gazes? From the silent dialogue established between these persons and ourselves? For these eyes directed toward us captivate us, make us captive.... There is a kind of mirror effect: the gaze of these strangers is our gaze beholding them. And the attention we give them, our way of looking them up and down, of staring at them, sends us back to the analysis of our own gaze, of what determines, codifies, and structures it. In the process, in a movement of introspection elicited by the bare gaze of these others, we come to see what constitutes us as individuals. Clearly, Struth's portraits are psychological portraits; psychological not in the sense that they illustrate some typology of characters or passions, but rather by virtue of this kind of nakedness of appearance which they fix and which yields these persons as they are in themselves, naturally, without any masks. In other words, with that air which "induces from body to soul."[1]

This very particular exchange only occurs with the portraits of individual persons. The family portraits are very different. They are dominated by the significance of family ties. With a clarity that is sometimes frightening, the relationships between parents and

1 Roland Barthes, *Camera Lucida*
 [New York: Hill & Wang, 1981].

children, brother and sister, are revealed before our eyes. A gaze, a wrinkle, a gesture, a posture are the subtle and enigmatic touches that compose the portrait of the family with its antagonisms, its bonds, its frustrations, its silent suffering, and its joys. Also, given the lack of external elements to inform us about the subjects of the individual portraits, it is rarely possible to make assumptions about their social status, whereas with the families the image teems with information, signaling the fundamental role of the family unit in the perpetuation of the codes specific to each social category. Thus both clothes and posture, the home, and a certain way of "meeting the gaze of the lens" all attest to a type of education, a way of being characteristic of one particular social category or another. Lastly, and this is perhaps the most disturbing feature, what is brought before our eyes is the singular power of heredity. From father to son to grandson, we observe the fascinating alchemy of permanent features, of the repetition of physiognomic characteristics, and the mysterious emergence of differences between members of the same family. Here too time is at work and photography suggests this fact as would a seventeenth-century Vanitas painting.

Also a form of Vanitas and an eminently classical theme of both painting and photography, the representation of flowers is given a singular treatment in Struth's universe. Here flowers are never the pretext for abstract formal games or the medium for an attempt at taxonomy. Rather, they partake in an attempt to render the individuality of each specimen, so that these images cannot be seen as the presentation of a motif taken from nature, but as real portraits of flowers.

In the individual, close-up portraits, the flower, like a face, offers to our gaze the delicacy of its substance, the purity of its form, the extreme fragility of its radiance—in a word, its perfect and perishable beauty; in the group portraits, where we are again struck by alterity amidst similarity, the effect of number, the force of the group, the

power of the species, convey the insistent feeling that, in spite of the inevitable, nature, by its constantly repeated cycle, celebrates permanence: the victory of life over death.

CHURCHES AND MUSEUMS

The intense dialogue with time and history that permeates Struth's œuvre has given rise to a set of photographs taken in churches and museums. Seen through the artist's lens, these privileged places of conservation and memory, where ancient forms of worship and modern rites are performed, become a fascinating testimony to our contemporary relation to works of art, and therefore to the status of art in our society. Working for the first time in large-format color, the photographer plays on a certain mimetic relationship between the object captured and the form used: the huge paintings and majestic architecture are thus rendered with a comparable emphasis, giving these photographs the imposing quality of old masterworks.

But the mimetic relationship with the artworks goes further than this: we can also observe it either by analogy or by contrast, in the beholders. Here, a group happens to form a diagonal that echoes the one in *The Raft of the Medusa*. There, children sitting on the floor form an oval pattern and mix of colors mirroring those of the Veronese painting they are looking at. Conversely, above the febrile agitation of a crowd in the Vatican, we see the unmoveable serenity of Raphael's frescos. Sometimes tender, sometimes ironic, these images of mass tourism subtly illustrate the paradoxes of a society that, in its desire to desacralize everything, has lost sight of the very notion of the sacred, leaving the crowds forever bereft of the deeper meanings of the works they come to see. However, this acknowledgment carries no hint of cynicism. On the contrary, the artist always allows for the possibility of a privileged encounter: that, for example, of an old man's mute

exchange with two Rembrandt portraits in the Kunsthistorische Museum in Vienna, or even the meditative stillness of a visitor in front of a Caillebotte painting at the Art Institute of Chicago.

However, these are exceptions; for in such places these encounters, these exchanges are characterized essentially by the physical presence of the beholders, rather than by some exercise in looking; which exercise is in fact made all the more difficult, and unlikely, by the size of the crowds. Hence the feeling of witnessing a kind of modern pilgrimage in which the relics are not contemplated for themselves but only insofar as they constitute the finality of a social ritual. In keeping with this logic, museology, whose intrusiveness is brought out by Struth, constitutes a further obstacle placed before the artwork. Thus what comes through in these images is not only the distance between men and the works—a physical distance imposed by the organization of museums—but also the great solitude of the masterpieces whose isolation, in spite of the ever growing crowds, is not only temporal—the distance of centuries—but results from the increasingly enigmatic character that they take on in an age in which art, now an object of consumption like any other, has—like photography?—lost its primitive aura as a transcendent object, its iconic status.

DIANCHI LU, SHANGHAI, 1995

In recent years Struth has made several visits to China. He has brought back a certain number of photographs of streets. These often colorful images stand out from the earlier photographs, notably by the marked presence of crowds. In them we find something of the feverish, chaotic agitation of the towns of the Far East, and, at the same time, the subjects, the framing, and the very atmosphere of these streets seem to indicate that Struth is taking a new approach to photography, as if the theme, like that of the museum photographs,

called for a new form. One particular image stands out from this series. Not because it is especially typical, but rather because it seems to be a synthesis of a number of older and more recent concerns.

It is a street in Shanghai. Two buildings from the last century offer a perspective on an adjoining street with its mesh of small modern buildings: the whole is fairly characterless. It has been raining. The tarmac shines beneath the milky screen of the sky from which a pale light falls. A few passers-by come and go while two others are busy around a merchant's stall. All in all, a perfectly ordinary scene of everyday life. But therein, to be sure, lies the magic of Thomas Struth's photographs. A magic that comes from this absence of striking subjects or views. A magic that has to do with this suspension of time, this freeze frame from the course of existence. And it is this nothing, this absence of subject that the artist photographs. And it is this nothing, this absence of subject that is fascinating. For everything, down to the slightest detail, is swathed in strangeness. Under the gaze of Thomas Struth, the visible is an enigma; and so is life. Photography presents this enigma, gives it an appearance. And the artist holds it out to us like a two-way mirror through which reality appears as it is at last: in the sublime and singular banality of its mystery.

HRIPSIMÉ VISSER | *Cultural Images* | TRANSLATION: DONALD MADER

BUCHLOH "What, in your understanding, is the essence of photography?"
STRUTH "It is a communicative and analytical medium. Today!"
BUCHLOH "Not a voyeuristic and fetishizing medium?"
STRUTH "No, not for me."[1]

Photographs by Thomas Struth are completely unspectacular. Every form of rhetoric is absent. The carefully framed images never lead the gaze to any one single formal or substantive motif. The depictions always unfold into a lamination of assembled parts, more or less complex but always in visual parity with one another. They are cityscapes, group [and individual] portraits, landscapes and shots of flowers, lucid, not to say "classic," in composition, and harmonious in the way their surface is divided, graphically or by color.

This austerity has a remarkable, fascinating effect, while the dry recital of formal principles and subject matter would scarcely seem to afford any cause for it. In the case of the early cityscapes, you could seek an explanation in the romantic literary and visual tradition in which the city appears as a living entity, a silent witness to scenes full of passion and violence, or, more formally, in the penchant for systematization, abstraction, and structure pursued by twentieth-century art. For the portraits you could maintain that by their gaze alone, directed at the lens, they compel us to look back and, despite the modesty of pose and composition, irrevocably supply us with the voyeuristic satisfactions that are just about synonymous with the photographic medium. But anyone who takes satisfaction in such explanations denies the intelligence and dynamism of Struth's work. The apparent simplicity of his approach is based on a balanced combination of analytic power and visual insight. The basic reason for the seductive quality of his intriguing œuvre lies much more in what he shows us that photography is still [or again] capable of, in a time overrun by images.

In the earliest interview with Struth that I know of, done in the time when he was still a student at the Academy at Düsseldorf, the young photographer says, "Photographs that impress me have no personal signature."[2] It is a remark that, to be sure, sounded logical coming from a student of Bernd and Hilla Becher, but that at the time irritated rather than inspired me. The effort that this pronouncement implied, to attain as great a degree of neutrality as possible, was perhaps interesting as a conceptual position, but appeared to want to reduce photography precisely to the transparency that was being so visibly and convincingly undermined by countless enthusiastic artists/photographers around that same time. Certainly what documentary photography was all about in that era was a new balance between maker and depiction in which the vision of a fragment of reality was emphasized rather than the possible "truth" of the reproduction of reality itself. That didn't exist; indeed it could not exist because every photograph, in the end, is an image, and therefore subjective.

In the 1980s the most interesting stage for investigating this balance between maker and depiction was the French DATAR project[3], which initially was oriented toward realizing photographic images of the "new" contemporary French landscape, in the broadest sense. Sadly enough, in the course of the project this documentary point of departure was exchanged for an all too great emphasis on the vision of the artist/photographer. In its final shape, the project, which also appeared in book form, became a sort of compendium of the more or less documentary vision that was operative in the 1980s, a visible "proof" of the wide range of possibilities for expression offered by photography. But while the notion of photographic "auteurship" was being made manifest in all this, among the countless, often brilliant photographs there were only a small number of shots that systematically analyzed the reality of the landscape, let alone documented it as it was being defined by historical or cultural forces. This relegated two essential possibilities for photography to

the sidelines, and photography as image in a strictly subjective or even painterly sense ruled the roost.

Thomas Struth himself did not escape this refinement of a vision—or, I might say, "method"—although from the outset it contained all the characteristic, implicit acknowledged connotations of neutrality and objectivity, such as an extremely limited number of precisely derived camera standpoints, lines that ran in a "logical," perspectival manner, and an absence of light and shadow effects. The sense of calm that this photographic self-control produced, in combination with the use of a time-consuming view camera, led logically to attention being given to the thing depicted itself. The power of his work lies precisely there, namely in asking, consistently and with conviction, that attention be paid to the reality of the subject.

Certainly, in the second half of the 1980s, Struth was not alone in this effort, either in Germany, or in other places. In the Netherlands, for instance, photographer Hans Aarsman put his SLR camera on the shelf and in 1988 and 1989 photographed the Dutch landscape with a large format camera, mounted on the roof of the camper van in which he traveled around. His change of format arose from the growing uneasiness with a peculiarly expressive photographic style as a determinative factor in the appreciation of photographs. He formulated his point of departure in this way: "No more credit line; in consequence, all recognition is given to what is photographed, not to the one who took the photo. The photographic approach must also become invisible. No exceptional compositions, no tricks which strike the eye, no interesting stuff."[4] No more than for Struth did this approach lead to completely transparent or anonymous images. Anyway, for Aarsman —apparently as a consequence of his background in journalism—there was a certain sense of anecdote, of photographic moments, of visual points to which a story or event could be connected. Struth was absolutely not interested in these; until the end of the

1980s his cityscapes and landscapes are characterized by the almost total absence of people, his portraits by concentration on the human gaze and by the positioning of people in space. There was good reason for Aarsman to call his photographs "Dutch Scenes," in that way explicitly referring to all the world being a stage, a stage set for human intervention and actions. Struth did not let himself be caught up by striking motifs, but in the course of wandering through cities and landscapes, he searched for precisely those locations that revealed to him the multiple layers of history, the assembled parts of an architectural culture, just as in his group portraits he tried to provide an image of mutual relationships and the deep roots people have in their own environment. Against the photographic moment he sets coagulated time; against chance, with its accompanying playful effects, he sets structural analysis.

In conversations Thomas Struth always emphasizes that his actual effort is put in chiefly during the period before the shot is taken: the morning walks through cities, the in-depth acquaintance with people, the slowly built-up understanding of the culturally defined structure of a landscape. These careful preparations point to the desire to make images that are the result of a process, a synthesis of impressions, knowledge, experience, and visual capabilities. It would be easy to throw back at Struth that this is a painterly desire, as the means that he employs here also might in some way indicate. His richly layered photographs are, however, both projections of mental images and also very precisely formulated photographic documents. The deeply anchored experience that comes first makes it possible for him to appropriate the reality to such a degree that he is able to make an "ordinary" photograph of it, as though it were entirely effortless.

The changes in his work since the late 1980s make it clear that the methodological limitations that Struth places on himself do not arise out of narrow formalism. The street scenes in China and Japan show people as an essential and entirely natural element of daily

life in those cultures. It is not improbable that his growing interest in the portrait is also attributable to this change. While in the early work, the process of looking on the part of the photographer overpowered everything else, and viewers were invited to identify themselves with his position, attention now appears to have shifted to the interaction between the viewer's process of looking and the subject's. This change was launched by what are termed the "Museum Photographs," which make looking so central that they are the only group in his work that can be understood as a commentary rather than as an analysis. This potential for interaction is one of the reasons why the suggestion of equality between the viewer and the subject of the image arises here. Unintentionally, you ascribe to the photographer an almost old-fashioned quality such as modesty, or perhaps even courtesy, that refuses to reduce people to victims or objects of desire. The other reasons are undoubtedly the sense of stasis that is the result of the long exposure time, and the compositional simplicity and equality of all the elements in the image, so characteristic of Struth.

It is curious that the overpowering feeling in Struth's work has to do with cultural images. By this, I certainly do not intend to say that he records well-chosen typologies of fashion or the contemporary sense of life for posterity, or even less that, like a scientist, he is assembling an archive of architecture or of family morals and customs in our time. His choice of subject is already too personal for that, even to the point of being so much connected to him that it does not allow one to speak of universal significance. Perhaps you could say—although possibly the photographer will not thank me for doing so—that he has given a new, recalcitrant dimension to the pursuit of archetypal images that is so deeply anchored in German photography of the twentieth century. It is new, because in his case the archetypal does not lead to typology, and recalcitrant because, going against the temper of the times, he shows us that communication does not need to be reduced to visual slogans, or photographs to illustrations of an image-critical model.

NOTES

1 Interview between Benjamin H. D. Buchloh and Thomas Struth, Paris, 30 Rue Vieille du Temple, 6/30 and 7/1/90, in: *Thomas Struth, Portraits,* exhibition catalogue Marian Goodman Gallery, New York, 1990, p. 32.

2 *In Deutschland* [ed. Klaus Honnef, Wilhelm Schürmann], exhibition catalogue Rheinisches Landesmuseum, Bonn, 1979, p. 88.

3 For information on the DATAR project, see "Interview with Bernhard Latarjet," *Perspektief* No. 28/29, June 1987, pp. 88–94.

4 Hans Aarsman, *Hollandse taferelen* [Amsterdam: n.p., 1989].

List of Plates

37 *Ma Yue Liang [On chair]*
SHANGHAI 1996
85 x 66,8 cm

39 *Chiesa dei Frari*
VENICE 1995
226 x 177,8 cm

40 *Todai-Ji*
NARA 1996
176 x 229,6 cm

43 *Nagato Bay*
KIWADO 1996
142 x 185 cm

44 *Aoyama Cemetery II*
TOKYO 1996
111,2 x 142 cm

45 *The Okutsu Family
in Tatami Room*
YAMAGUCHI 1996
104,7 x 135 cm

47 *Go and Ayaka Okutsu*
YAMAGUCHI 1996
53 x 69,3 cm

48 *Hillside Road*
KIWADO 1996
45,2 x 56,2 cm

49 *Traditional
Japanese House II*
KIWADO 1996
42,4 x 55,7 cm

50 *Lane along Yuonfang Lu*
SHANGHAI 1995
41,8 x 54 cm

51 *Crossing with Passers-by*
WUHAN 1995
91,5 x 116 cm

52 *Jiang-Han Lu*
WUHAN 1995
90 x 116 cm

53 *People on Fuxing Dong Lu*
SHANGHAI 1997
88 x 112 cm

55 *Zhou Xing Fa*
LANZHOU 1997
69,5 x 87 cm

57 *Wangfujing Dong Lu*
SHANGHAI 1997
83,5 x 111,5 cm

58 *Tien An Men*
BEIJING 1997
176 x 218 cm

60 *Luo Yong-Jin und Yao Quanjun*
BEIJING 1997
75,2 x 94,5 cm

61 *Sashi Er Lu II*
SHANGHAI 1996
47,5 x 58 cm

63 *The Ma Family*
SHANGHAI 1996
84,6 x 104,2 cm

64 *San Zaccaria*
VENICE 1995
180 x 228,5 cm

67 *Chicago Board of Trade I*
CHICAGO 1990
95,7 x 75,8 cm

69 *Museum of Modern Art I*
NEW YORK 1994
180 x 238 cm

71 *Art Institute of Chicago I*
CHICAGO 1990
174 x 206 cm

73 *Art Institute of Chicago II*
CHICAGO 1990
184 x 219 cm

74 *Via Giuseppe Verdi*
MILAN 1992
44 x 55 cm

75 *Via Emilio Cornalia
[with highrise]*
MILAN 1992
44,5 x 55 cm

76 *Via Giuseppe Baretti*
MILAN 1992
43 x 53 cm

77 *Via San Marco*
MILAN 1992
42 x 51 cm

78 *Baumgruppe bei
Rutschwil —
Landscape N°25*
WINTERTHUR 1993
81 x 103 cm

79 *Waldstrasse auf
dem Lindberg —
Landscape N°3*
WINTERTHUR 1992
82,5 x 94 cm

81 *Feldweg mit Scheune bei Welsikon
— Landscape N°28*
WINTERTHUR 1993
69,5 x 88 cm

83 *Feldweg in Seuzach – Landscape N°5*
WINTERTHUR 1991
74 x 110 cm

85 *Garten am Lindberg mit
Sonnenblumen – Landscape N°1*
WINTERTHUR 1991
70 x 90 cm

87 *Hannah und Jana–Maria*
DÜSSELDORF 1997
79,5 x 56,7 cm

88 *Galleria dell' Accademia I*
VENICE 1992
184,5 x 228,3 cm

91 *Richard Sennett*
NEW YORK 1997
90 x 112 cm

93 *Gerhard Richter I*
COLOGNE 1993
81 x 59,4 cm

95 *Galleria dell' Accademia II*
VENICE 1995
176 x 138,5 cm

97 *Barbara Flynn*
NEW YORK 1996
68 x 84 cm

99 *Anna Grefe [standing]*
DÜSSELDORF 1997
88 x 61 cm

101 *Stanze di Raffaello I*
ROME 1990
191 x 138 cm

103 *Grosse Kornblume – Plant N°47*
DÜSSELDORF 1993
58 x 46 cm

105 *Einzelne Buschrose – Plant N°42*
DÜSSELDORF 1993
58 x 46 cm

106 *Einjähriger blauer Rittersporn
– Plant N°3*
WINTERTHUR 1991
58 x 46 cm

107 *Helle Sonnenblumen – Plant N°1*
WINTERTHUR 1991
58 x 44 cm

109 *Schafgarbe – Plant N°2*
WINTERTHUR 1991
58 x 44 cm

111 *Malve – Plant N°6*
WINTERTHUR 1992
58 x 46 cm

Plates

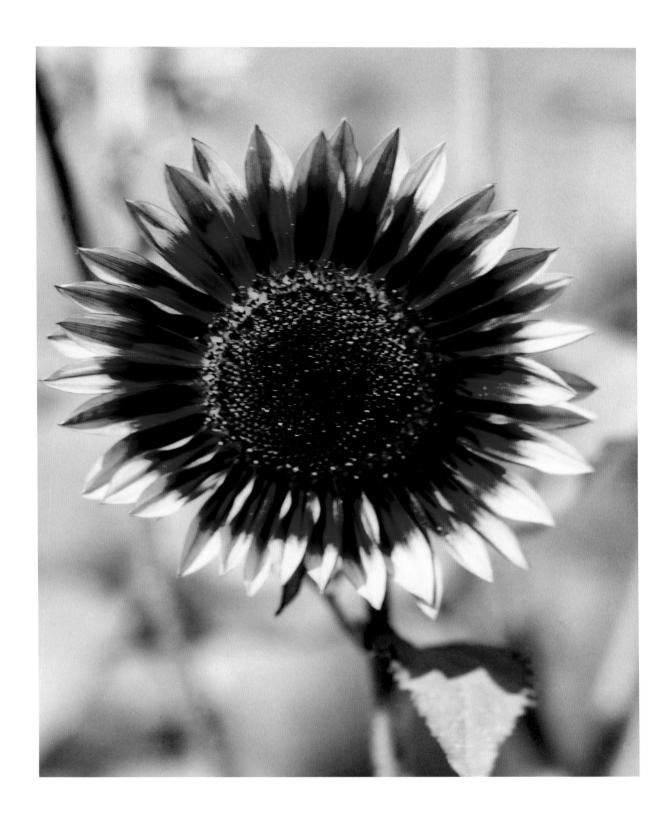

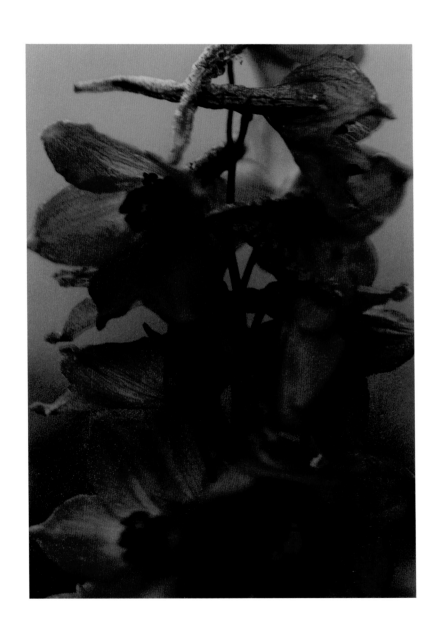

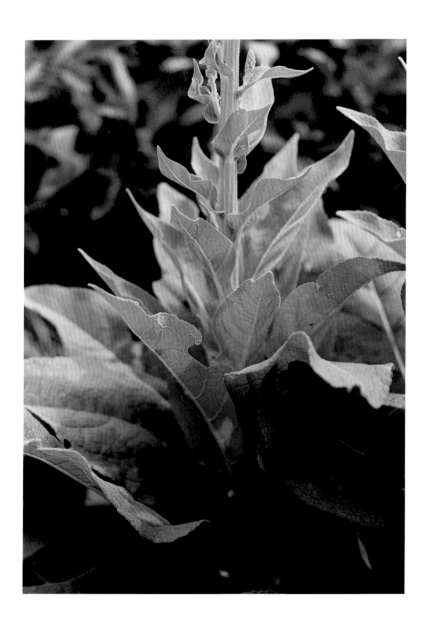

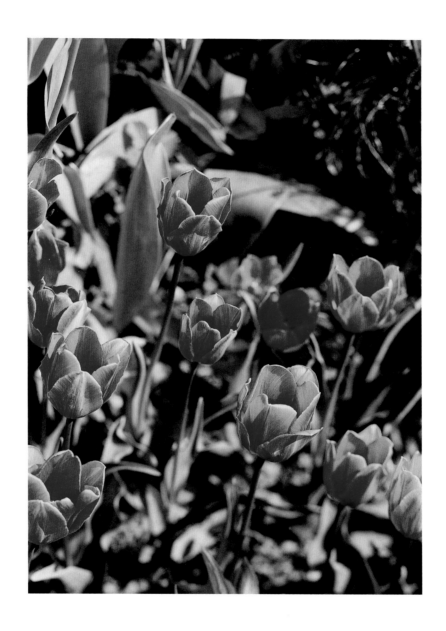

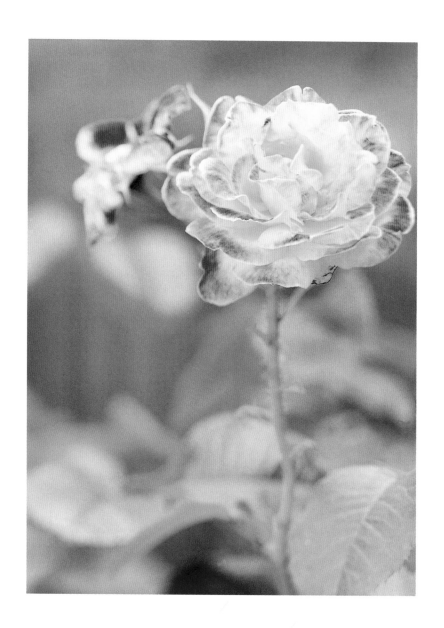

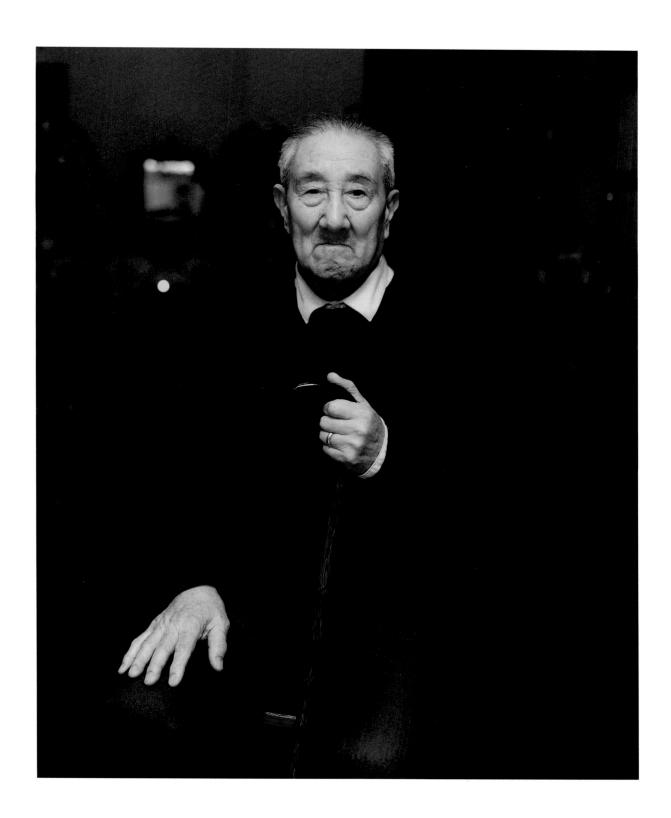

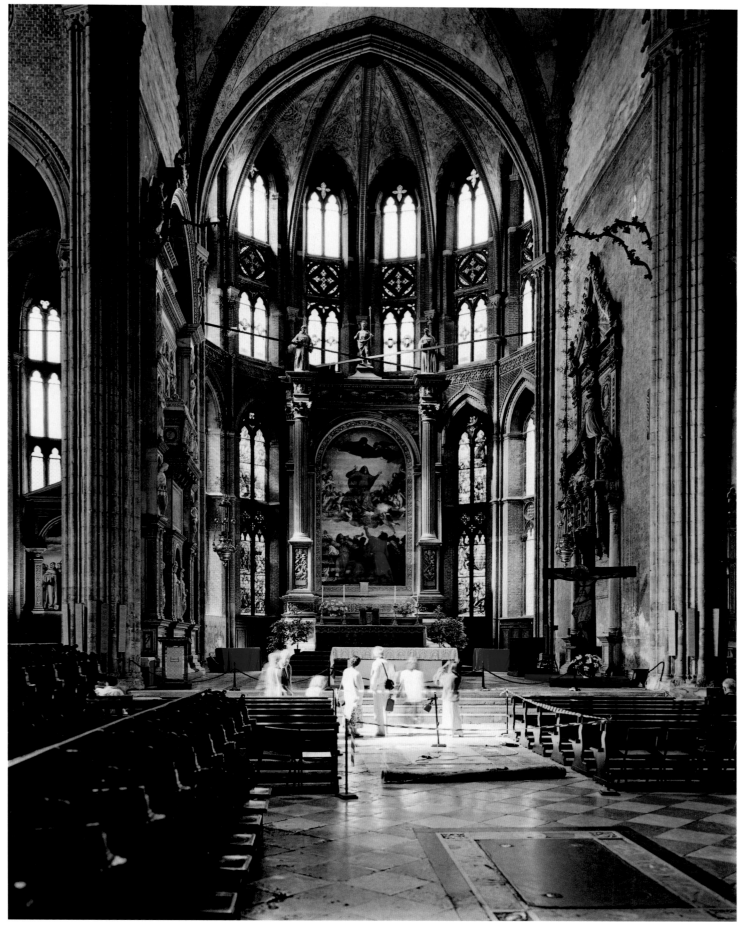

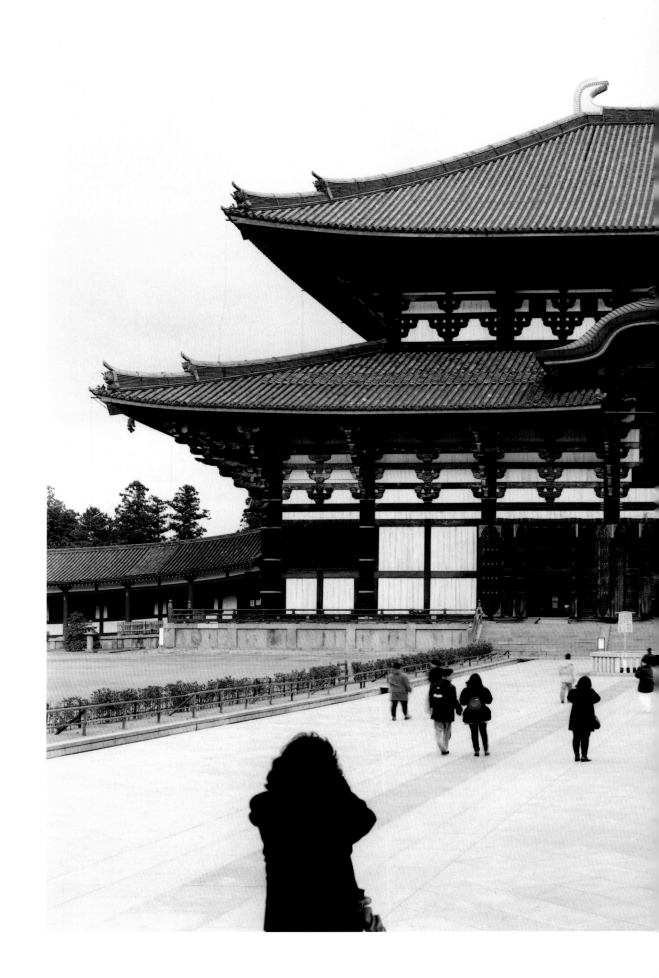

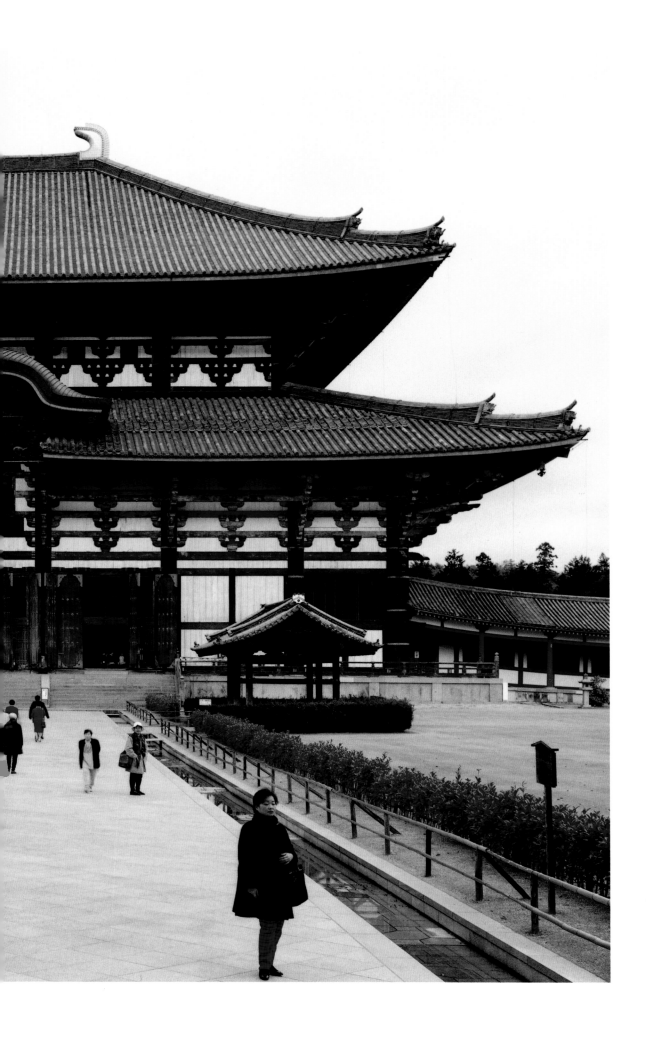

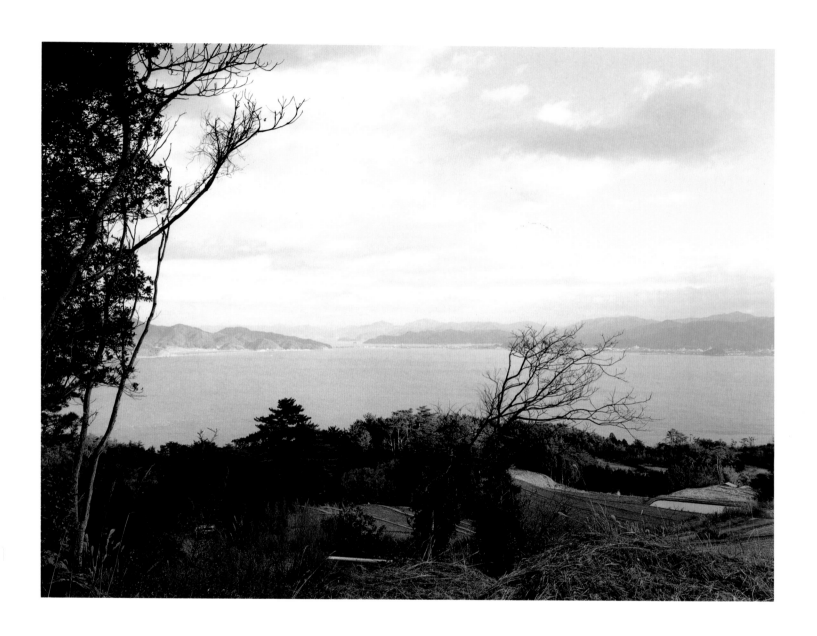

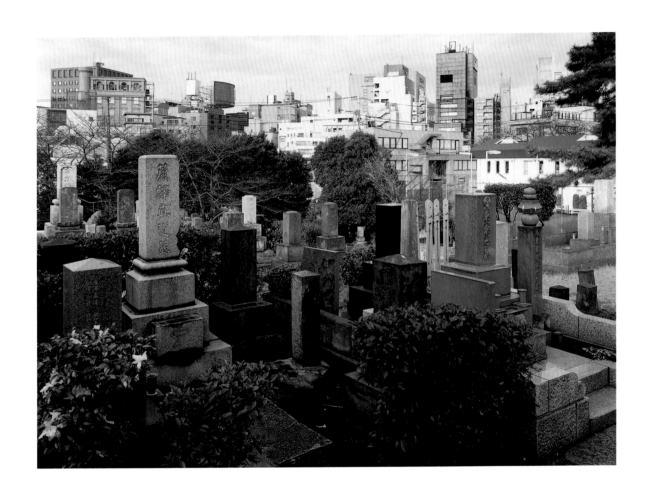

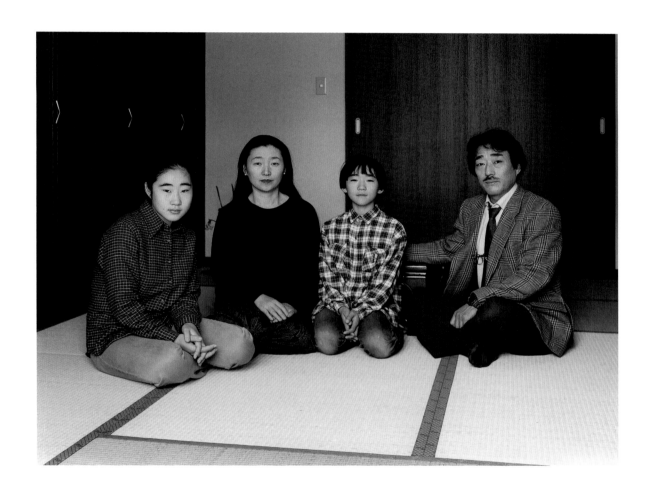

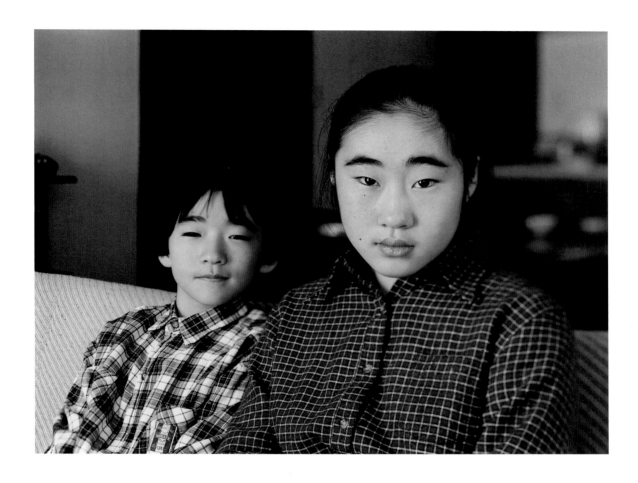

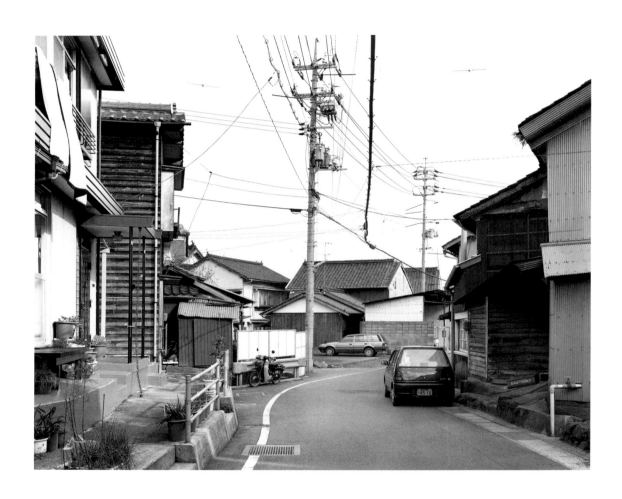

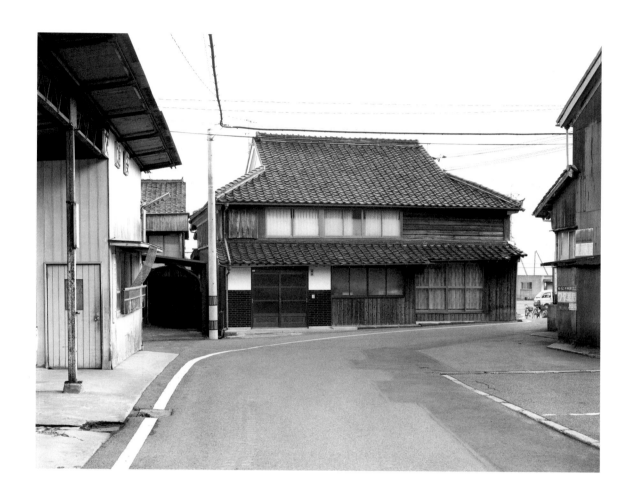

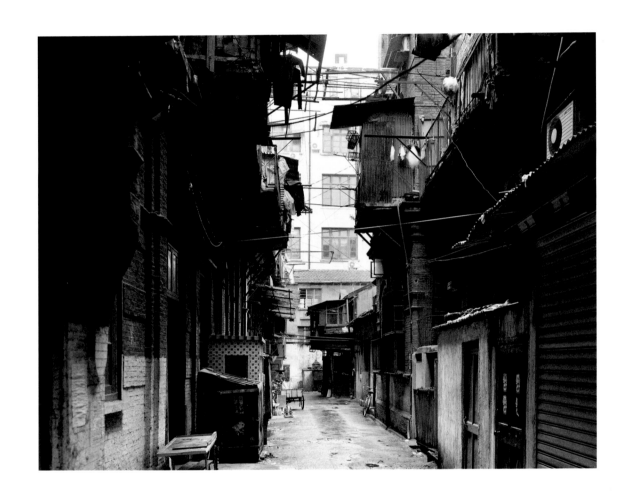

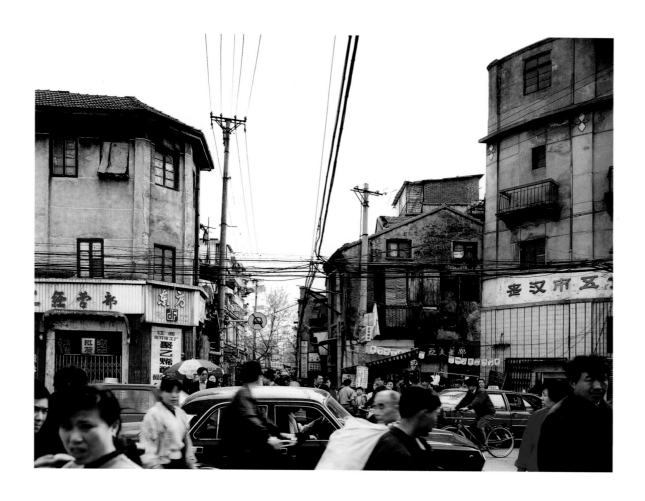

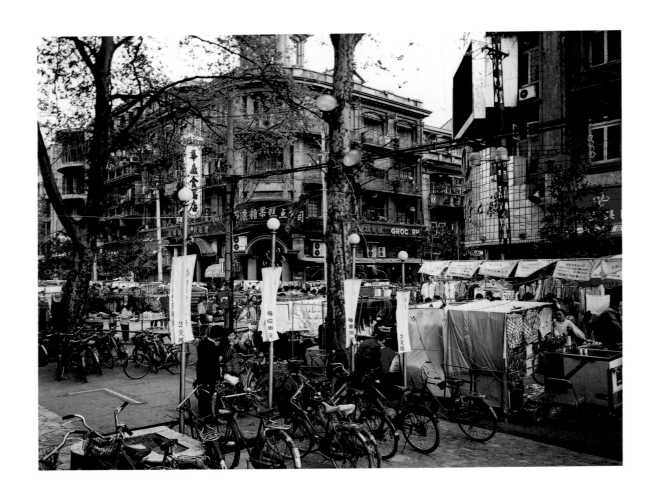

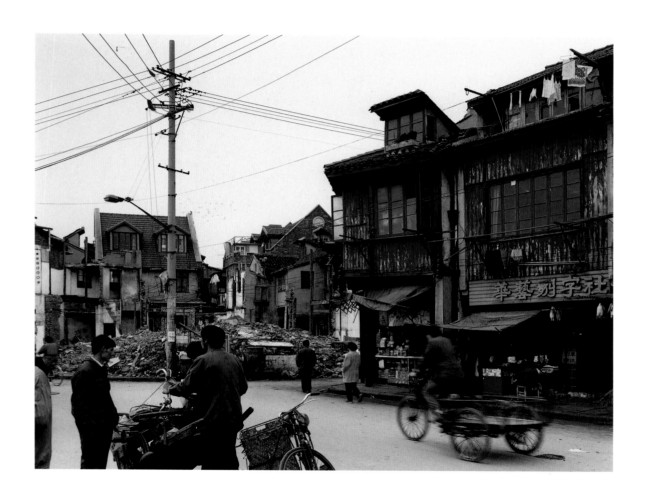

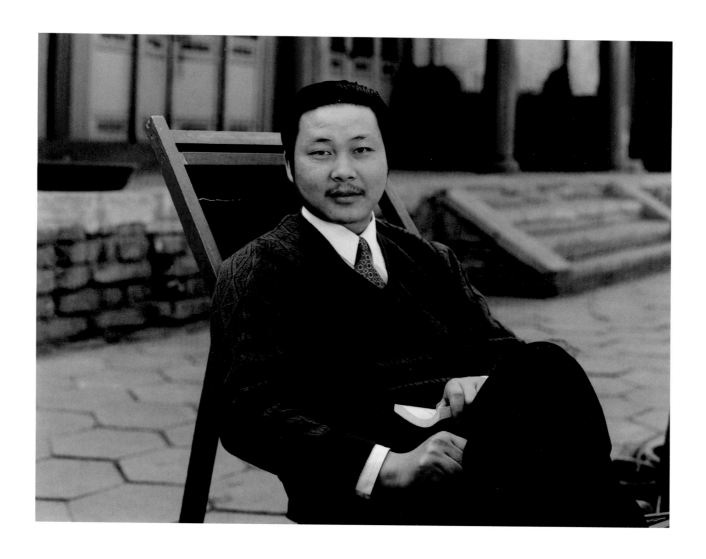

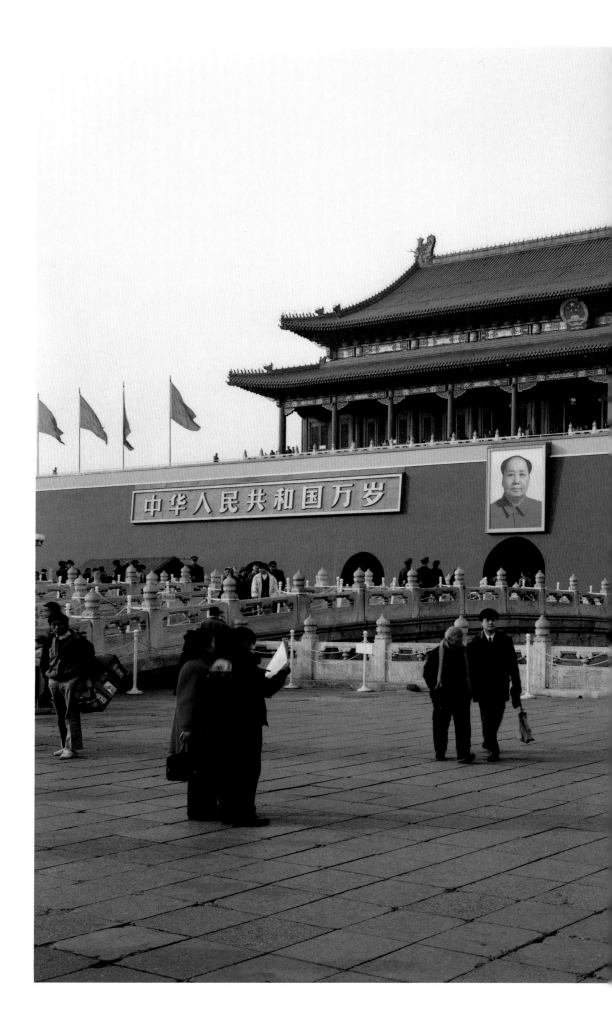

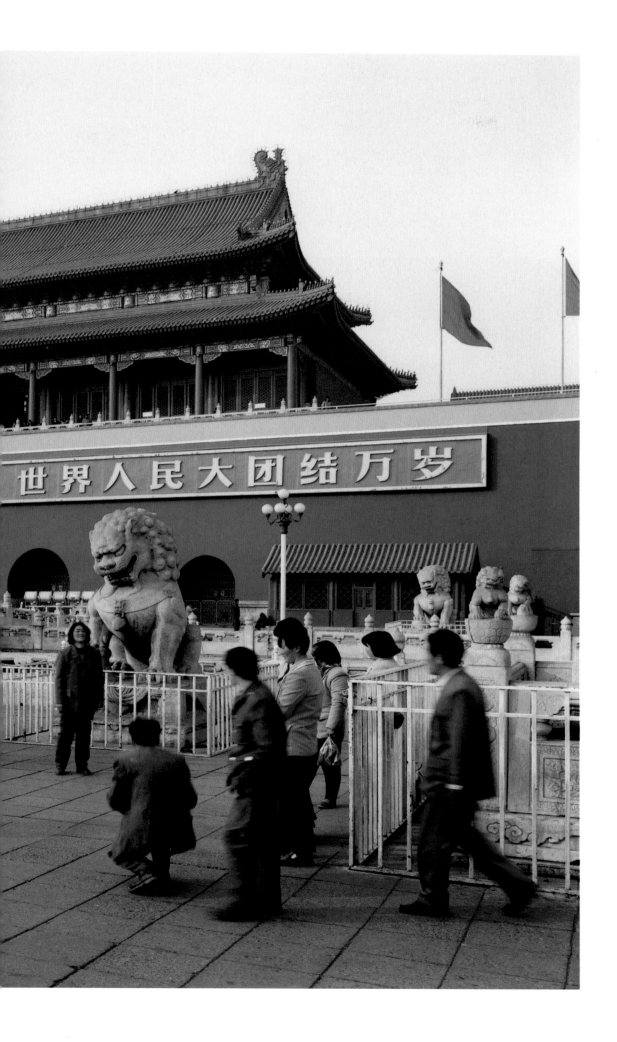

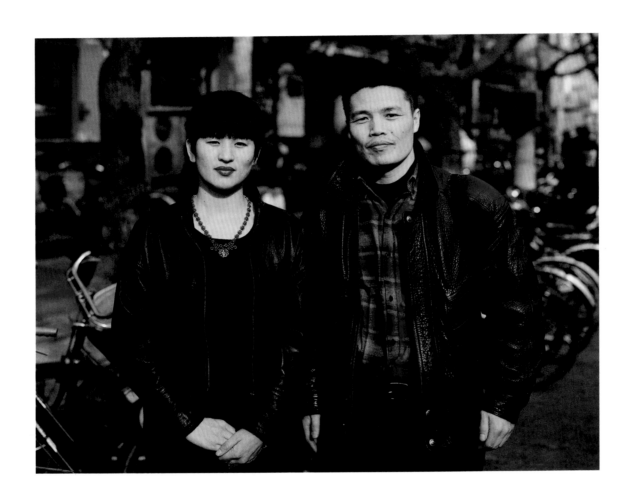

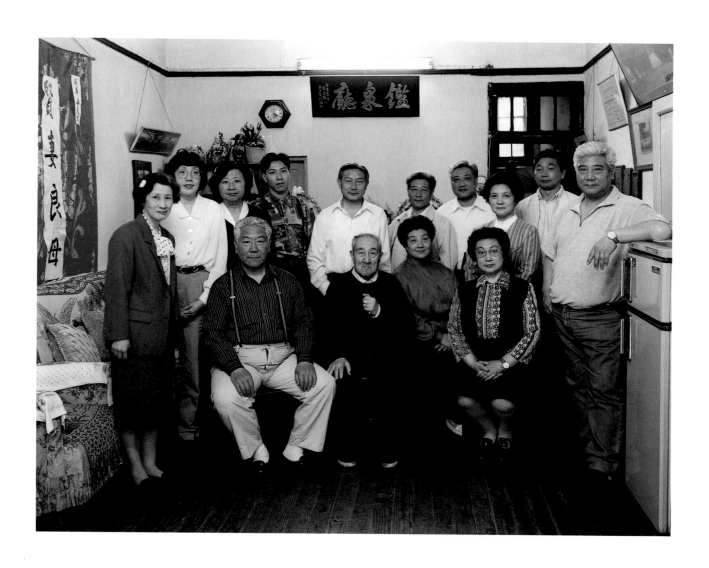

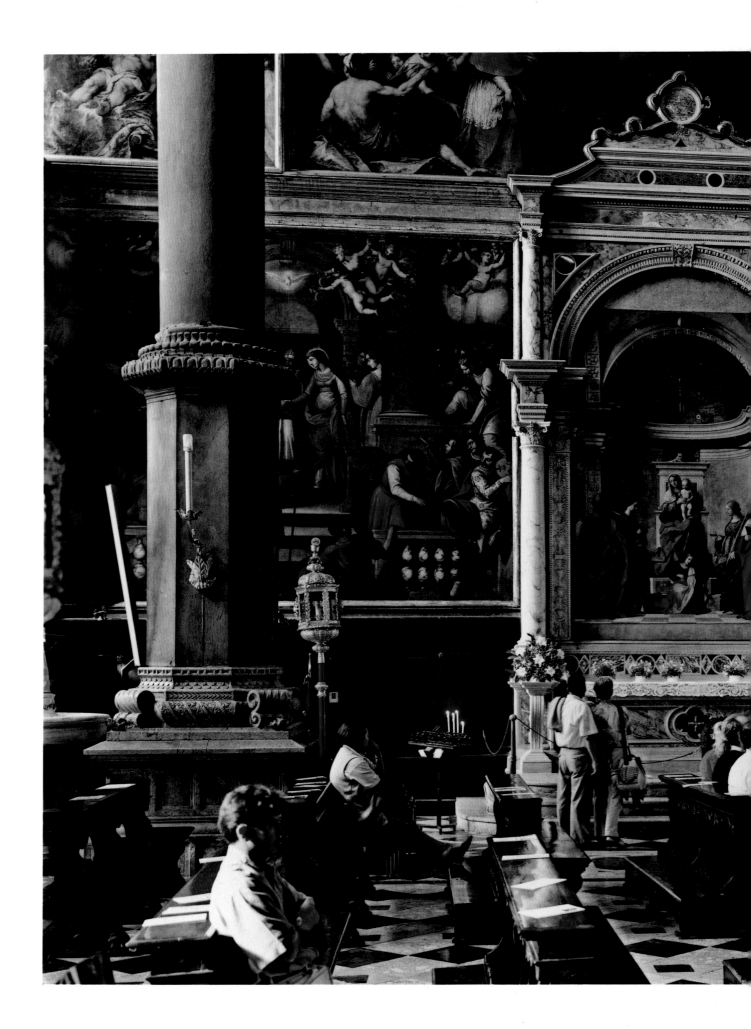

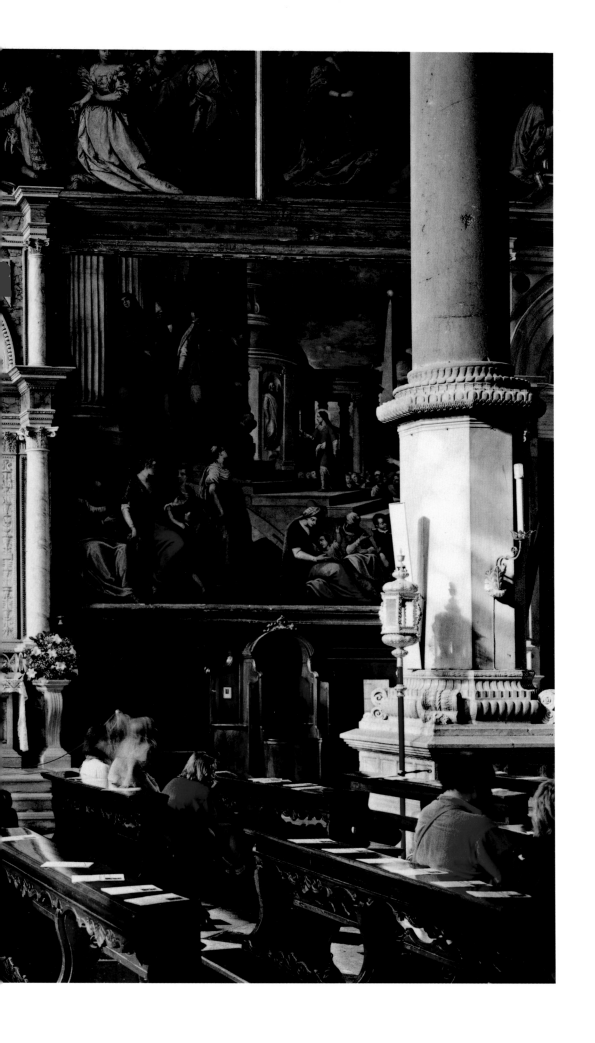

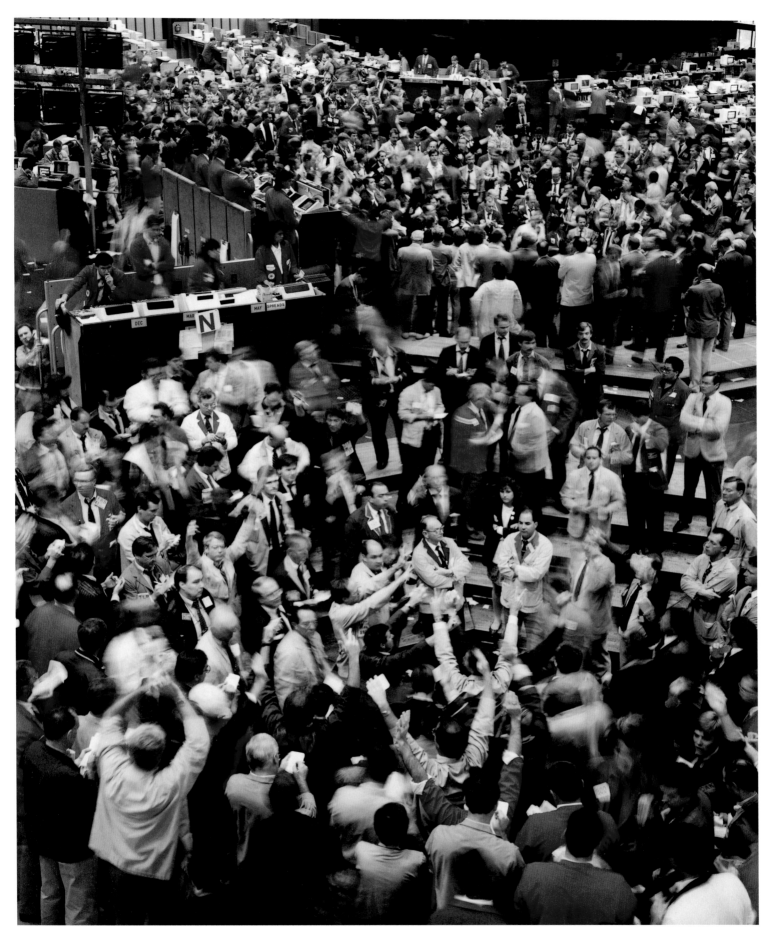

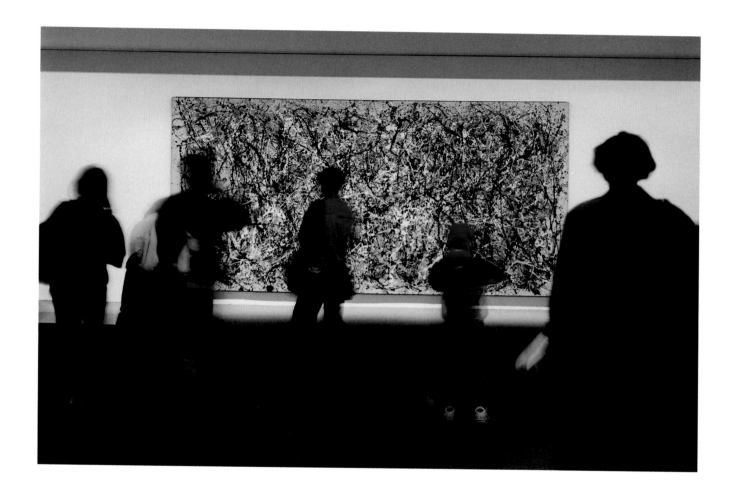

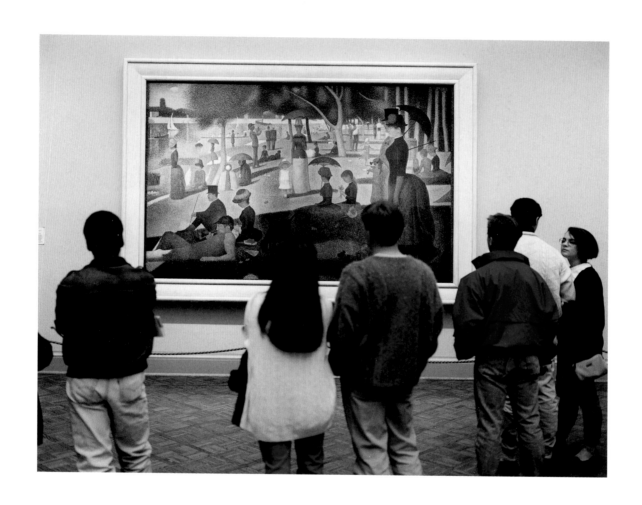

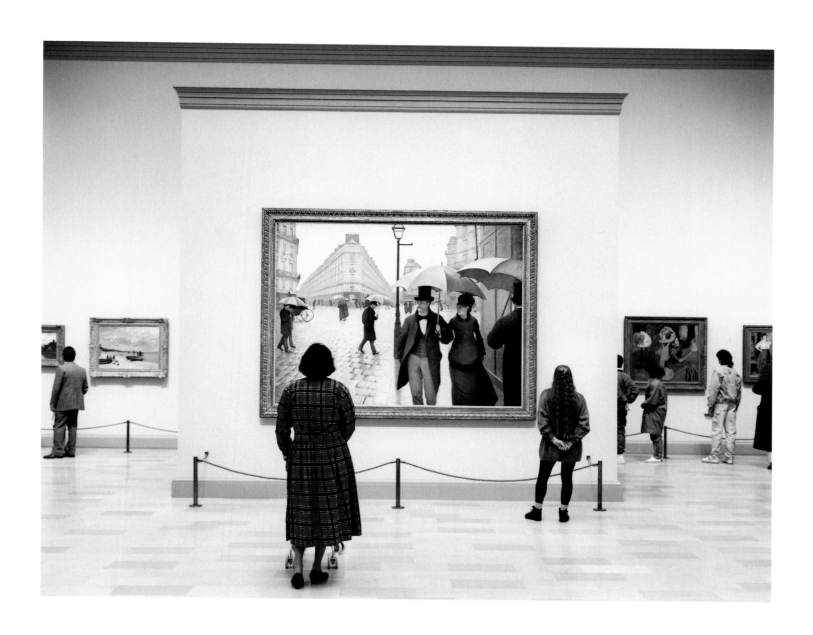

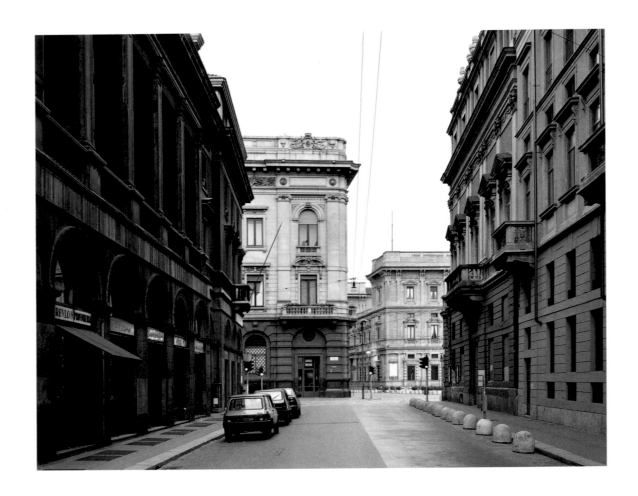

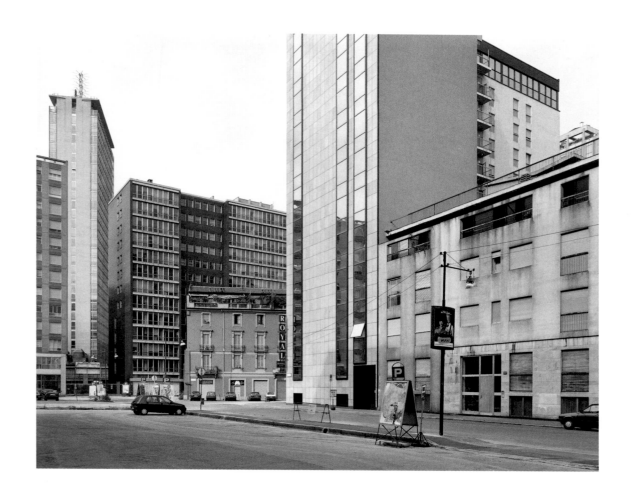

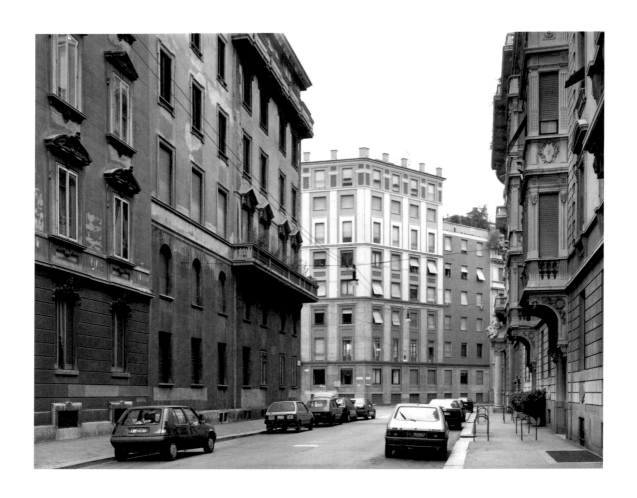

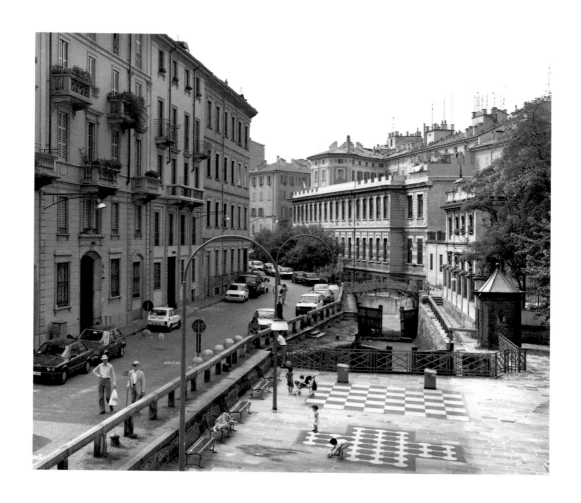

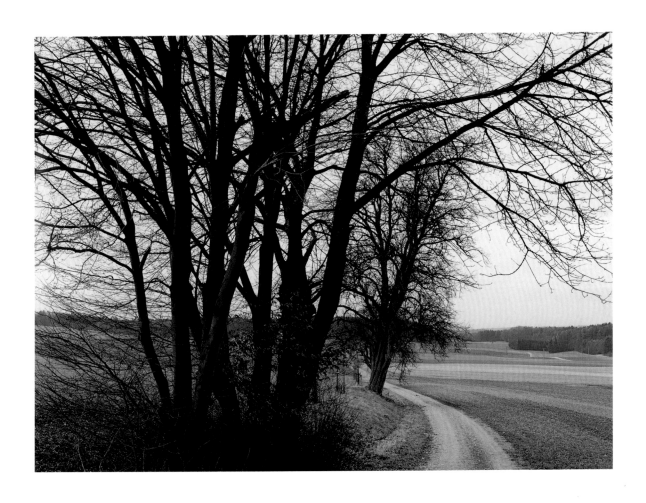

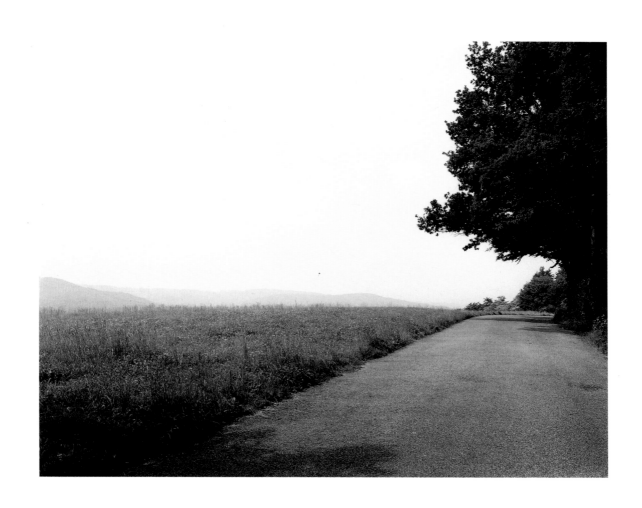

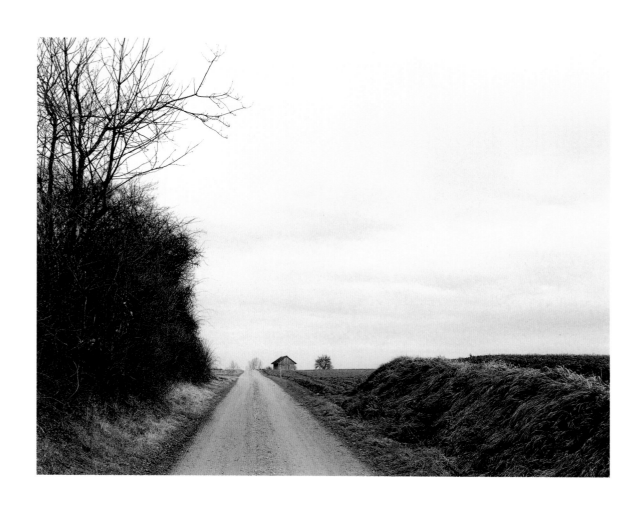

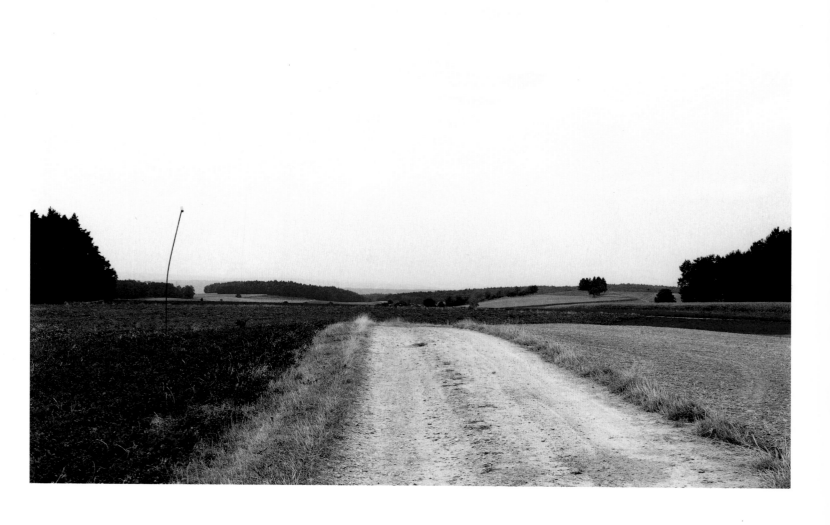

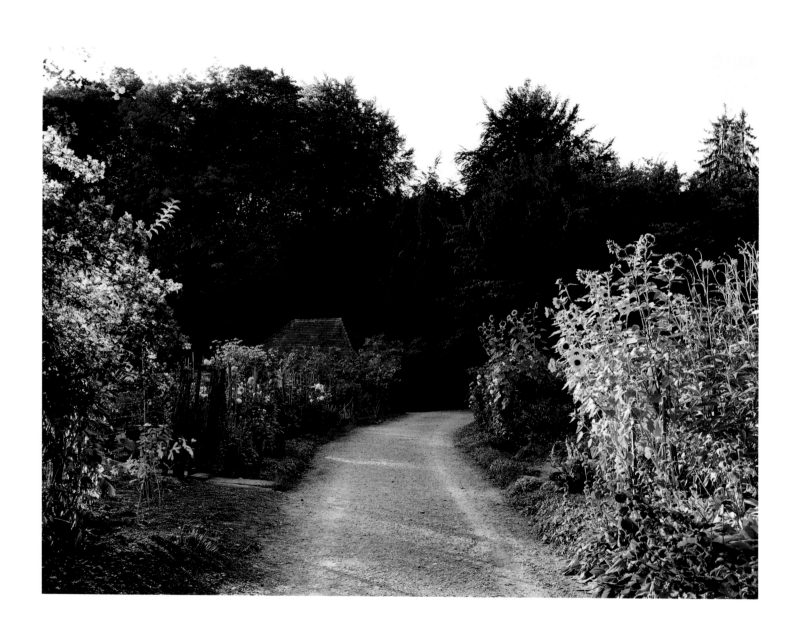

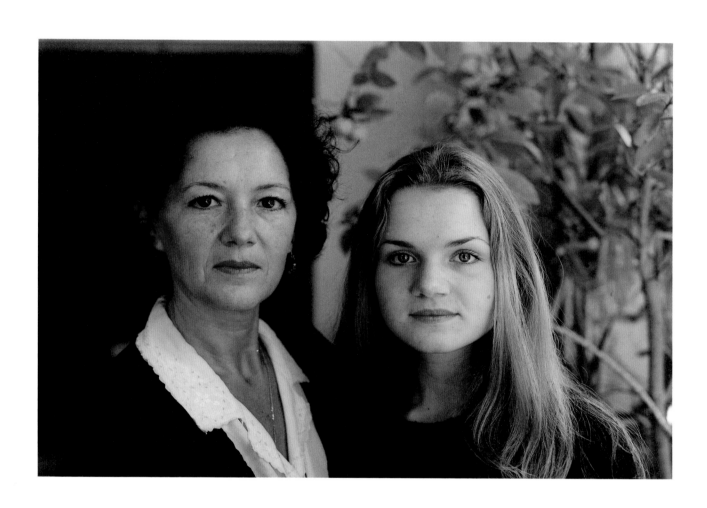

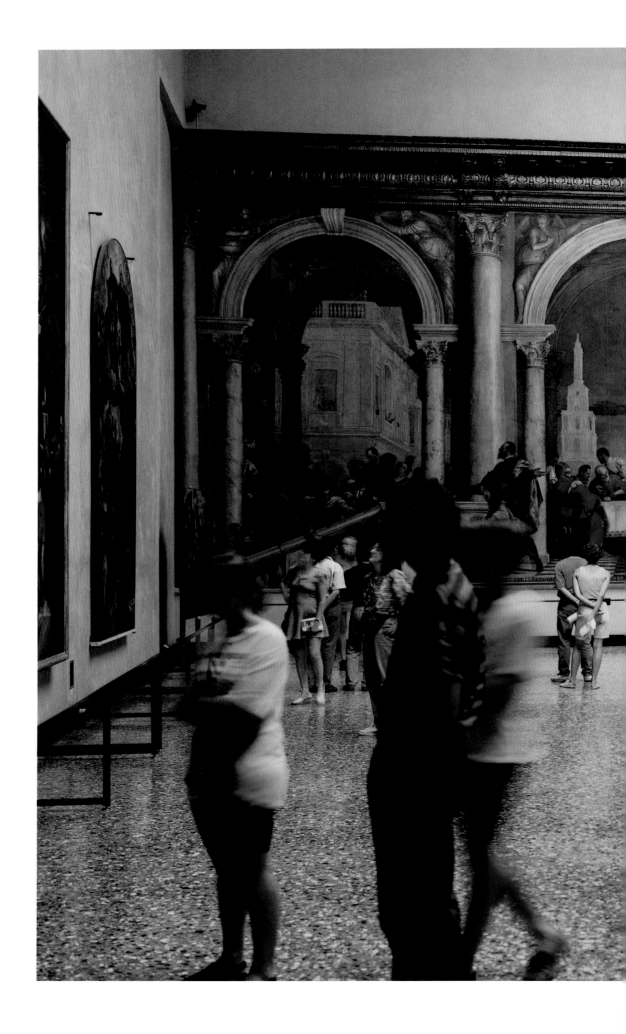

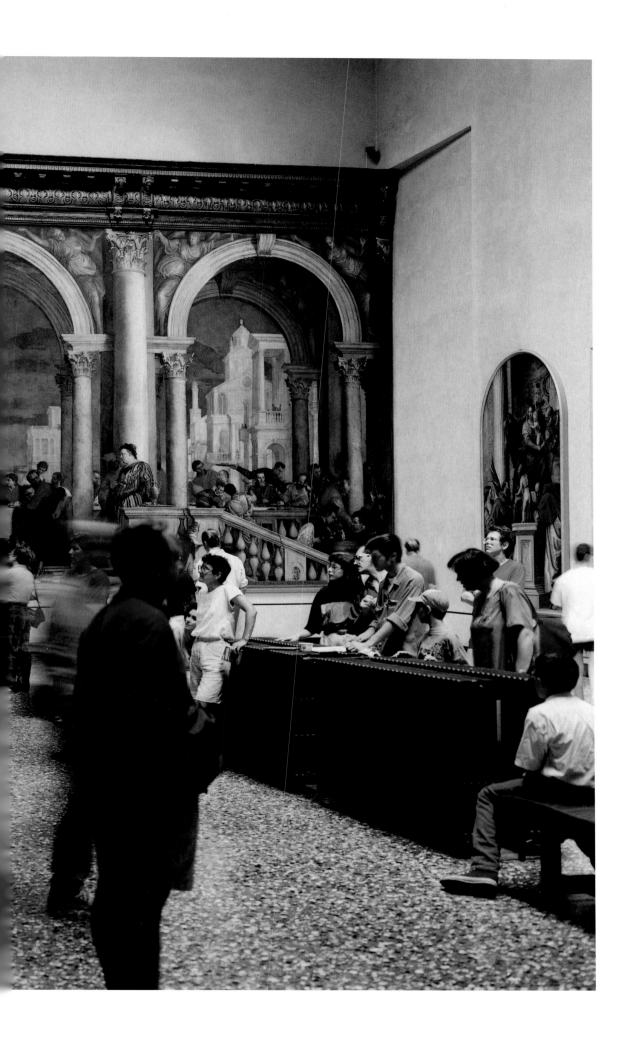

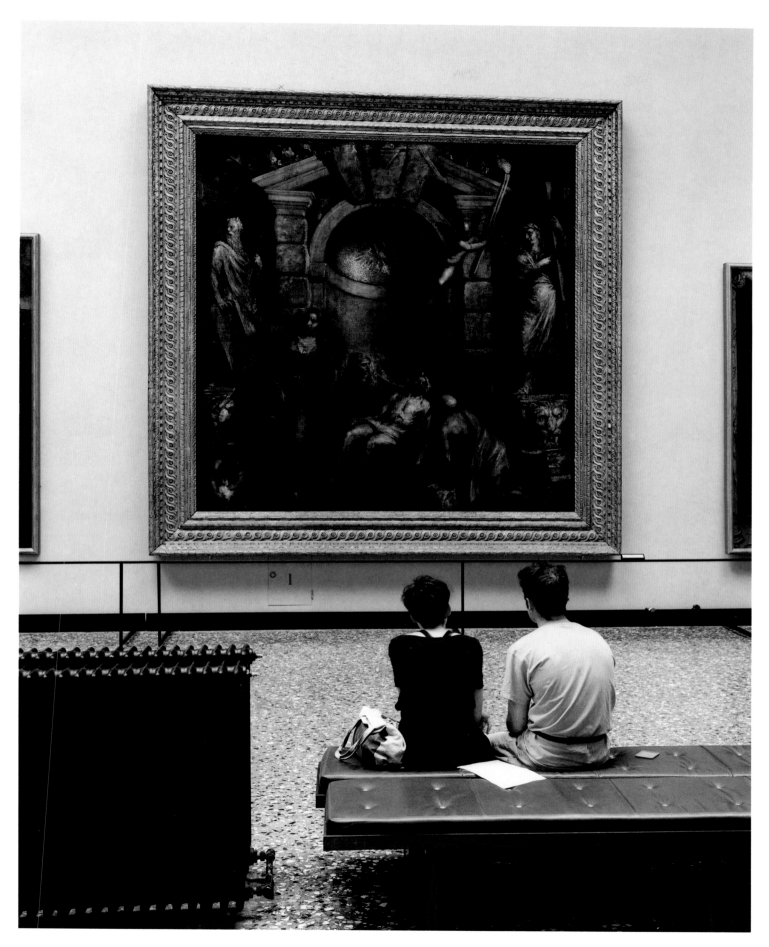

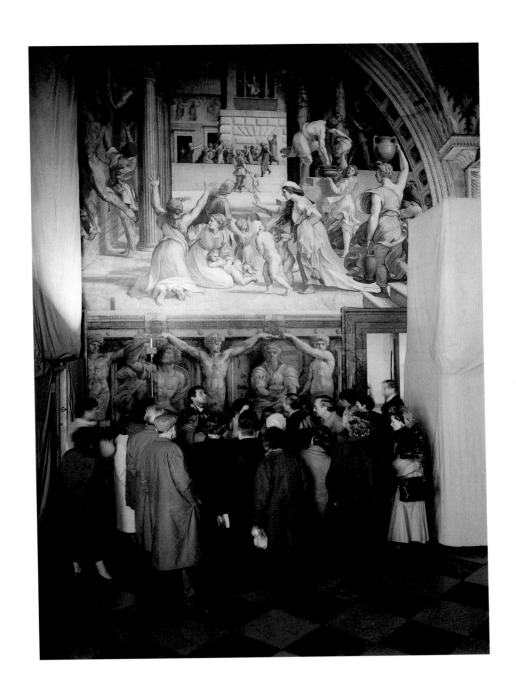

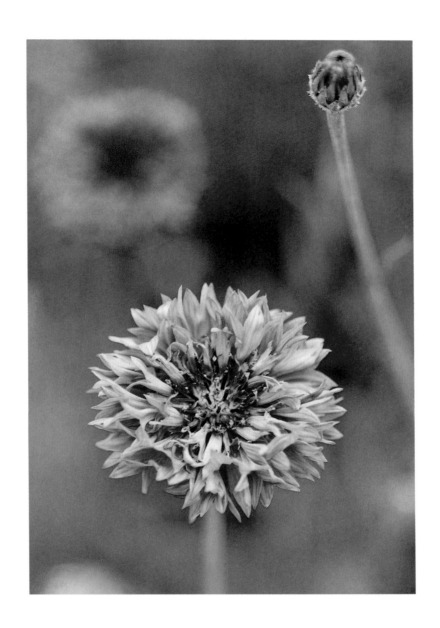

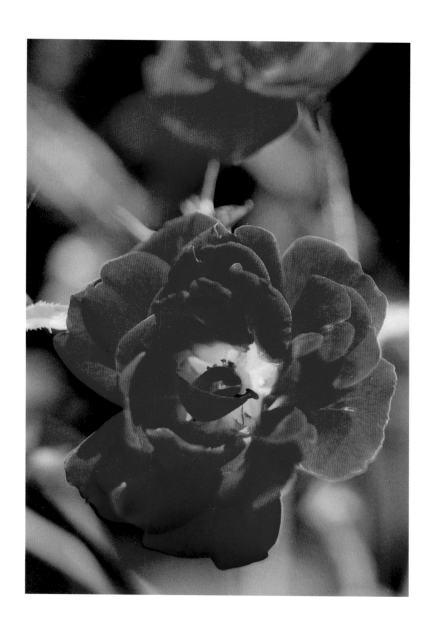

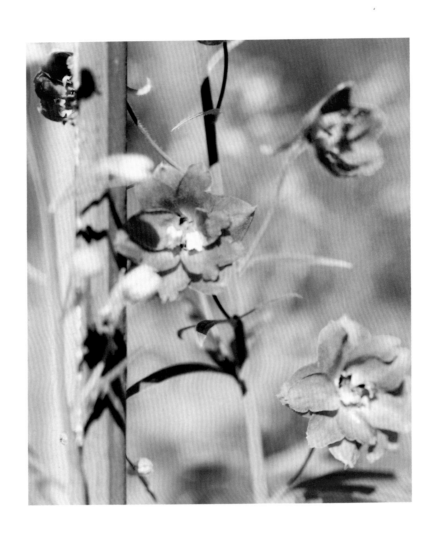

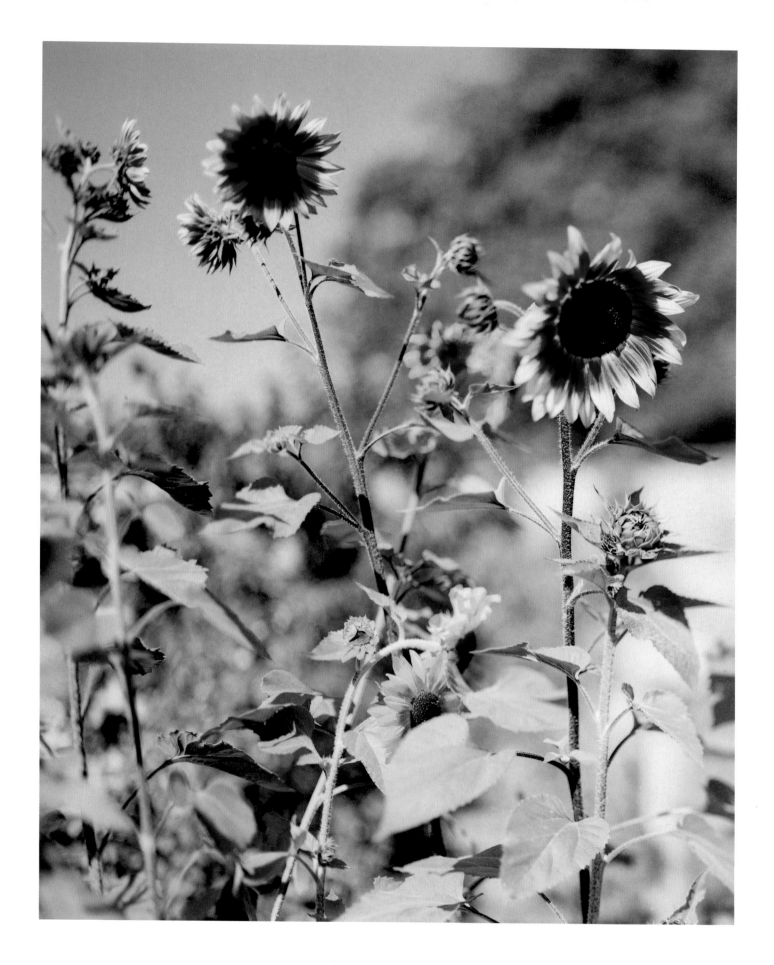

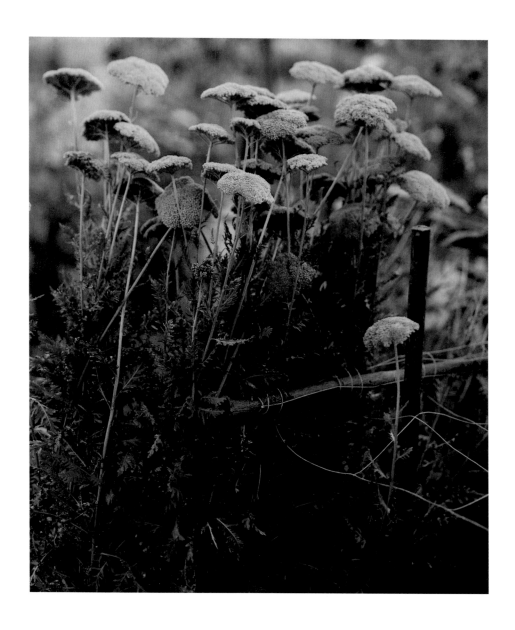

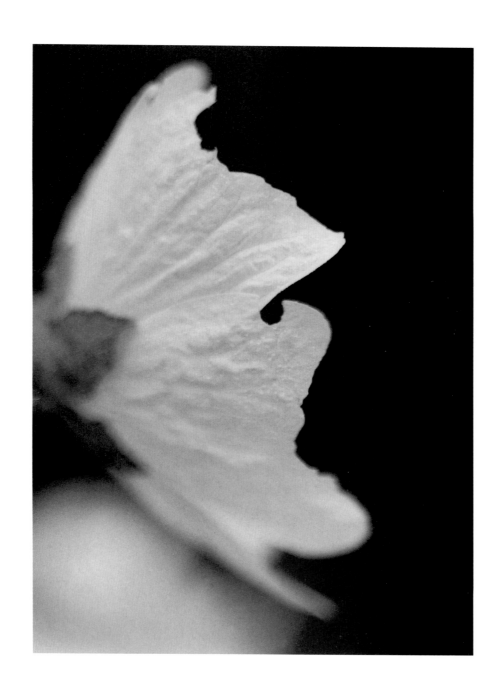

RÉGIS DURAND | *A Common Measure*

The question of experience can be approached nowadays only with an acknowledgement that it is no longer accessible to us. For just as modern man has been deprived of his biography, his experience has likewise been expropriated. Indeed, his incapacity to have and communicate experiences is perhaps one of the few self-certainties to which he can lay claim.

Giorgio Agamben, *Infancy and History: Essays on the Destruction of Experience*

At the heart of Thomas Struth's work and the apparent diversity of its subjects, there lies, I believe, the idea of experience. This œuvre could indeed be read as an attempt to understand and, using particular systems, to render the experience that is the encounter with various aspects of the outside world.

What is meant here by "experience?" Not the highlighting of an "artistic," formal, or existential singularity, but rather a "voice" that, while certainly individual, also retains a link with a history and with meanings that can be shared. It is therefore something that owes almost nothing to chance encounters or discoveries, and even less to a mise-en-scène of the self, something that consists in being constantly responsive to the experience of the outside, in attesting to one's presence in the present moment. It is, in a way, a very general and very banal idea, but one that, when seriously applied, determines precise artistic criteria.[1]

The idea of testimony should not necessarily be associated with the documentary approach, which, as we know, can easily lose its way in the flux of media fashions, or, worse, in the pure and simple obscenity of exploiting the world's misery. During an interview given in 1988, Struth replied as follows when asked if he would describe his work "as political and social": "Certainly, even if not, of course, in a direct manner. As far as my work on urban space is concerned, it is political and social in the sense I described before, of an analysis and a synthesis of our way of living in this society. But I also think that my

interest in portraiture, which I started to make five years ago, works in that direction, as a sort of testimony to people living in our age." [2]

That, indeed, is the key question: How are we to live in time, in the age, our age, that of "our way of living in this society?" As an answer, we could put forward the following hypothesis: analyses and syntheses, constantly reiterated and displaced in each photograph, make visible something of that "slow piling one on top of the other of thin, transparent layers" of time that constitutes the present.

The expression "slow piling one on top of the other of thin, transparent layers" is from Walter Benjamin, who uses it to describe how narrative is "revealed through the layers of a variety of retellings." [3] True, there is nothing narrative in the strict sense in Struth's work, but, by virtue of its articulation in long series that overlap in time, his œuvre does perhaps capture something of what, according to Benjamin, constitutes the power and originality of storytelling: the fact that it conveys the weight of an experience of history and time, sharing it with the reader so that in turn it becomes an experience for him too. Whereas the novel [the two terms are placed in opposition here] has lost its link with the collective epic tradition and is now only the work of a solitary individual. Beneath this literary term [narration], we therefore need to understand the capacity a work has of bearing witness to a "common measure," [4] which is to say, to a sharing and a freedom sustained in a "field of oscillations."

The possibility of shared experience is very much present in Struth's work, far from the imposed authority of information or events, and this is what gives his photographs their potency. For, as Benjamin observed, "The value of information does not survive the moment in which it was new. It lives only at that moment; it has to surrender to it completely and explain itself to it without losing any time. A story is different. It does not expend itself. It preserves and concentrates its strength and is capable of releasing it even

after a long time."[5] This is borne out in the views of streets taken at different times and in different places. The "information" they yield is free of all anecdote and all pressure of the instant. On the contrary, it consists in gathering from those places all the forces, the layers of time deposited by history that gave them their form. In the same way, the splendid photographs taken in museums bring before us a paradoxical temporal sedimentation, which includes the particular configuration of the instant but can in no sense be reduced to it.

For here the analogy with Benajmin's rich idea of "storytelling" comes to an end. The temporality at play in visual works is different: it is that of the encounter, whereas narration implies consecutiveness and an unfolding in time [of reading or listening]. Joyce spoke admirably of this "ineluctable modality of the visible," the necessary simultaneity of the *nebeneinander*, which he opposed to the no less necessary consequence of the audible, the *nacheinander*.[6] Certainly, the visual image does not rule out lingering contemplation, indeed it often encourages it: that is the case with most of Thomas Struth's photographs. But the time here is a particular one, without a chronological unfolding, in which everything seems immediately given in the instant, simultaneously, and where what is at stake is precisely the place and the role that the spectator will come and take up in front of the image. This mixture of certainty and uncertainty, this rapid oscillation between fascination and specularity, is quite the contrary of the long and calm time of the story [what Benjamin called its "gentle flame"]. In front of a photographic work, however peaceful the subject, I am summoned to situate [or "imagine myself" as Struth says] in space and in time. And the great strength of Struth's work lies in the acuity that it imparts to this questioning, this knot of paradoxes.

To measure what is at stake in these paradoxes, as well as Struth's singular position in this regard, we can again summon Benjamin, in one of those dialectical movements so often found at the heart of his thought. At the beginning of the famous essay entitled "The

Task of the Translator" we read: "In the appreciation of a work of art or an art form, consideration of the receiver never proves fruitful. Not only is any reference to a certain public or its representatives misleading, but even the concept of an 'ideal' receiver is detrimental in the theoretical consideration of art, since all it posits is the existence and nature of man as such. Art, in the same way, posits man's physical and spiritual existence, but in none of its works is it concerned with his response. No poem is intended for the reader, no picture for the beholder, no symphony for the listener."[7]

This goes against the grain of the contemporary, "democratic" approach to art, which, as in the various aspects of "reception theory," makes the viewer [reader, or listener] a veritable agent of the work, one of its "creators." And indeed, Benjamin himself is never very far from this position in other texts, when he describes the play of dialectical exchange between ourselves, the spectators, and what we look at, which "looks at us in return."[8] The work of numerous contemporary artists does not seem to sit easily with a point of view as apparently idealistic as the one that argues that "no picture [is] for the beholder." The works of Thomas Struth generally construct an inclusive, complex space in which the "enunciative" position of the artist, and the historical consciousness, notably, of the beholder, are deliberately taken into account. The descriptive capacity of photography is thus used to capture temporal "deposits," the layering of a history of places and persons, which are palpable right down to their most current manifestations, that is to say, those that bear the mark of the instant when the shot was taken.[9]

The works of Thomas Struth make visible things or beings that seem to look like what may have existed in the world at one given moment or another, in one place or another. However, these images are no mere copies, no mirrorlike simulacra, which ultimately do no more than show us an image of ourselves and the world around us. They are profoundly transformed, and it is for this reason only that they convey and generate experience. The

photographs of streets and museums say this very clearly; the portraits, the landscapes, and the flowers much less so, for here a first circle of transformations and experience interposes itself much more forcefully, that of painting, of that "painterly eye" described by Rupert Pfab, which is more the gaze of paint than the gaze of the painter.[10] The "pictorial moment" is therefore decisive in Thomas Struth's constitution of a shared experience, irrespective of whether his approach is as close as possible or radically distanced. This is probably what explains the fact that this relation can only be established in a slow developmental process, through series that continue and intersect in time rather than running out of wind with the feeling of having "really done" a "subject." Duration is also the form taken by a certain form of dissatisfaction that impels the artist to keep working at a motif in a series of continuous variations and developments. And it is perhaps in this respect that Richter's influence on Struth's work is most visible. As with Richter, genre [portraiture, landscape, etc.] is one of the ways of restoring our awareness of what exists around us—people, houses, works of art—which the effect of habit has made almost invisible.

Thus photography regains its value as a "historically determined visual concretion." What remains to be determined [this would be the other pole evoked in negative by Benjamin's remark about the denial of the beholder] is to which complex individual subjectivity, or subjectivities, a body of work such as Thomas Struth's is currently addressed.

NOTES

1 Issue 50/51 of *Parkett* arrived just as I was finishing this text. It contains several essays on Thomas Struth, notably Norman Bryson's "Not Cold, not too Warm" [pp. 157–159]. Bryson uses the term "civility" to characterize the artist's position in his attempt to bring forth this experience. This seems to me to point in the same direction, albeit in a different register, to what I am trying to establish here.

2 Interview with Giovanna Minelli, November 14, 1998, *Another Objectivity* [Idea Books, 1989], p. 192.

3 Walter Benjamin, "The Storyteller," *Illuminations* [Glasgow: Fontana, 1977], p. 93.

4 Walter Benjamin, op. cit., p. 84.

5 Walter Benjamin, op. cit., p. 90.

6 James Joyce, *Ulysses,* ch. 13 ["Proteus"].

7 "The Task of the Translator," *Illuminations* [Glasgow: Fontana, 1973], p. 69.

8 Notably in "On Some Motifs in Baudelaire," *Illuminations*, p. 190, and in his writings on aura. More generally, reception is present in Benjamin's writings on notions such as "remembrance" or "awakening," and in anything that affords an escape from what Benjamin Buchloh called "the continual process of transformation of visual experience into specularity" ["Les Allégories de la peinture," in *Gerhard Richter* [cat.], Musée d'art moderne de la Ville de Paris, 1993, vol. II. p. 57]. I have evoked this dialectic

of the gaze in several essays, notably "Le monde de Hannah Collins," Hannah Collins [cat.], Centre national de la photographie/Echo Books, 1997, and "Les Images laïques de Thomas Ruff," *Thomas Ruff* [cat], Centre national de la photographie / Actes Sud, 1997.

9 I have analyzed the way in which this work attests to our presence in the world and in time in "Thomas Struth, Realism and Recollection," *Art Press,* May 1996.

10 "Landscape as Portrait—Remarks on Landscape as a Motif of Thomas Struth," *Thomas Struth—Landschaften, Photografien 1991–1993.*

JAMES LINGWOOD | *Composure [or On Being Still]*

Thomas Struth's photographs over the past twenty years constitute a sustained and concentrated inquiry into the ethics and aesthetics of seeing. Struth's research is not motivated solely by an interest in what we can see—the surfaces of places, people, and paintings—important though the subjects of his photographs are to him. He is equally preoccupied with the question of the way that we see. Because the way that we see, the manners and the modes of seeing, are a powerful signifier of our social being, of the way that we are, with ourselves and with others—of the way that we negotiate our relations with people around us, with "Strangers and Friends," to return to the title of an earlier book of Struth's.

In many of the earlier black and white photographs Struth has made in cities in Europe and the United States, the viewer's vision is organized down the middle of the street by the classical device of a central perspective. From the beginning of his career Struth never committed himself to the absolutely rigorous application of a preconceived system as exemplified by Bernd and Hilla Bechers's typologies, but his deployment of this organizing device nonetheless runs like a core through the work. At first this device directs the relationship between the viewer and the picture in an overt way: it is almost as if this relation is the subject of the work. Gradually, it becomes less overtly central as Struth's repertoire of approaches broadens, but its significance as a means of underpinning the construction of the experience of the viewer has remained nonetheless important. The precise positioning of the head of the Bellini Madonna in the center of the picture Struth made in San Zaccaria, Venice, is one example; the placing of the elderly patriarch in the middle of the group portrait of the Ma Family, Shanghai, in 1996 is another.

As the forms of looking in Struth's photographs expand to embrace portraits of friends and families, and photographs of people looking at pictures in museums, the nature of Struth's interest in vision becomes more apparent. The subjects of the photographs are also viewers, as much as the viewer of the photographs is also the subject. They look at some-

thing—a person, or a painting, and they look at the person looking at them. And each of these relationships connotes a particular attitude to this process. On one level, Struth's "Museum Photographs" consciously chart varying degrees of absorption, from the solitary silver-haired man looking at a pair of Rembrandts in the Kunsthistorisches Museum in Vienna, to a woman in the Art Institute of Chicago scrutinizing Caillebotte's painting of an urban scene in Paris, or a jostling mass of visitors in the Raphael Stanze in Rome. But at the same time that Struth embraces the importance of vision, he holds back from celebrating its primacy. Vision doesn't confirm the dominion of the viewer over the subject, or even necessarily the centrality of the viewer within a picture of the world—as was implicit in the construction of the classical landscape tradition. Much as he knows about the uses and abuses of photography, Struth is determined to propose a different kind of relation, one that does not equate seeing with power or control so much as with a certain [or uncertain] kind of responsibility. Even as he continues to use the most classical of organizing devices, his photographs offer and ask for an equality of vision rather than imposing a hierarchy.

The photograph taken inside the church of San Zaccaria in Venice in 1995 exemplifies Struth's enquiry. Within a single composition Struth incorporates a virtual typology of ways of looking. Several visitors, sitting on the church pews either in small groups or alone, appear to be looking toward an altar. The young man in the foreground is staring ahead with particular concentration. Other visitors are looking around or gazing up at the ceiling. There's a couple looking at the great Bellini Madonna and Child. Probably, like many of the people sitting down, they're tourists but it's not possible to be sure. Some of the visitors to the church could equally have come to worship. There's a feeling that the people in the picture are believers, although what they believe in we cannot know: the value of culture perhaps, or the power of the image, or just the possibility of believing in a secular age.

Within the panels on the walls, there are an almost vertiginous number of figures looking at different incidents or points of interest. Amongst this mass of images, there is one point of absolute stillness—Giovanni Bellini's great Madonna and Child. On the right hand side of Bellini's painting stands the figure of a saint immersed in a book. Of all the figures in the church, ancient and modern, this is the figure who is most absorbed in a world of his own. His absorption echoes that of the viewer outside of the picture looking at all of these people looking.

It's easy to speculate as to what other photographers might have done with similar material and a different attitude to the subject: the easy quarry of contemporary tourism exposed in a flashy freeze-frame, transformed into a grotesque of cultural consumption, or a figure of contemplation reduced to a cipher of sentimentality. Like many photographers, Struth is obliged to watch and wait. But, whilst the contingency of the moment will always complement the structure of the work rather than detract from it, he is not interested in capturing something, or catching someone out. As his concern with the photography of people—both those he knows and those he does not—has developed, Struth has taken extreme care to resist the temptations of the voyeur. On the contrary, this picture, like many others Struth has taken in museums and church interiors, embodies a powerful feeling of empathy with people the artist cannot know, of respect for their capacity to look and perhaps to believe.

With considerable precision, Struth has established a conceptual and compositional framework for the photograph. And with considerable patience, he waits for the protagonists to form their own picture. Neither the subjects nor their beliefs are looked down on or elevated. No celebration, no condescension. The picture has a sense of equality, a lack of hierarchy which belies its context. Indeed it seems that the picture is not only formed by the artist: it has been allowed to form itself, to make its own configuration within a frame

[Struth only very rarely crops his negatives] and a structure [the device of central perspective is still used with mathematical precision; the heads of the Madonna and child, minute in comparison with the successive columns, illusionistic and real, which frame them, are at the absolute center of the composition]. In an uncynical, unmanipulative way, Struth's pictures seem to be concerned with an idea—although not an ideal—of belief in equality and responsibility.

The empathy of the picture in San Zaccaria is echoed by the singular approach Struth has brought to the problem of portraiture, an approach exemplified by the recent portraits of the Yamato and Okatsu families in Yamaguchi, or the Ma family in Shanghai, or the single portraits of friends in Germany, China, and Japan. What characterizes these portraits is the openness with which the artist engages with his subjects. And what emerges from this approach is not primarily a matter of composition, classical though the configuration of people in the family portraits often seems to be. It is more a matter of composure, a state of being, a kind of stillness which emanates from the ways that the individuals have formed themselves into a group, presented themselves to, and looked openly at, the photographer. The composure of the subjects creates, almost paradoxically, a pictorial vitality—in the relationship between the viewer and the picture—which far exceeds the immediacy of those portraitists who strive to seize the moment in all its glamorous transience. The poise [in distinction to the pose] of the portraits foregrounds an active mentality, an engagement with exterior relations, a looking out rather than a withdrawing into the interior. Rather than seeking to seize the instant, Struth's photographs in their very lack of expressivity enable the act of looking to be distilled, stretched, given a different quality of time.

It is no coincidence that this quality of composure permeates Struth's recent work in Japan—landscapes as well as portraits. It relates to Struth's progressive involvement in Eastern culture and to the practice and philosophy of Wu style Tai-Qi Quan, which Struth

has studied for many years. In Tai-Qi Quan the forms of movement are refined, concentrated, and given exceptional poise. Struth is by no means the first Western photographer on whom Eastern culture has exercised a profound hold. Cartier-Bresson, for example, [whose credo of "the decisive moment" stands at some distance from Struth's own philosophy of photography] could find in Zen Buddhism a precedent for his approach to the photographic act. But Struth's involvement is of a different order—a kind of slow immersion with long-term consequences and its effect, though never exaggerated, is significant. The qualities of poise and precision which characterize many aspects of Japanese culture from Zen archery to the organizing of the cultivated landscape have a parallel presence within the still compositions of Struth's work.

Recently, Struth has extended his research into the relationship between stillness and concentration a stage further and into another medium. Early in 1998, in a large space in the Sprengel Museum in Hanover, he installed a room of video portraits. The visitor encounters five large faces, looking intently. They do nothing but look at you, for a period which extends well beyond any capacity to look back. Their heads, and their gazes, are as fixed as possible. Inevitably, however, there is some movement—eyes blinking, hair moving in a breeze, or someone passing behind—and these movements emphazise the stillness, the concentration of the sitter. As in Struth's earlier works, this relationship creates a sense of equality, of works of portraiture which transcend a fascination with physiognomy and become deeply considered inquiries into the act of looking, and its importance.

Biography

1954	Born in Geldern [lower Rhine]
1973–80	Studies at the Kunstakademie Düsseldorf
1978	Is awarded the Kunstakademie's New York scholarship
1980–82	Does his national citizen's service in a community center
1993–96	Teaches photography at the Staatliche Hochschule für Gestaltung in Karlsruhe
1997	Is awarded "Spectrum" International Photography Prize of Lower Saxony

Exhibitions

1978 P.S.1, NEW YORK

1980 Galerie Rüdiger Schöttle, MUNICH

1981 Stadtmuseum Düsseldorf
 (with Roswitha Ronkholz)

1985 Galerie Rüdiger Schöttle, MUNICH

1986 Gallery Shimada, YAMAGUCHI

1987 Galerie Max Hetzler, COLOGNE
 Kunsthalle Bern, BERN [catalogue]
 Westfälisches Landesmuseum MÜNSTER
 (with Siah Armajani)
 Prefectural Museum of Art, YAMAGUCHI
 Fruitmarket Gallery, EDINBURGH

1988 Galerie Meert-Rihoux, BRUSSELS
 Portikus, FRANKFURT AM MAIN
 (with Siah Armajani)
 Galerie Rüdiger Schöttle, MUNICH

1989 The Clocktower, NEW YORK
 (with Andreas Gursky)
 Galerie Max Hetzler, COLOGNE
 Halle Sud, GENEVA [catalogue]
 Galerie Peter Pakesch, VIENNA

1990 The Renaissance Society at the
 University of Chicago, CHICAGO [catalogue]
 Marian Goodman Gallery, NEW YORK [catalogue]
 Galerie Giovanna Minelli, PARIS
 Galerie Urbi et Orbi, PARIS
 Galerie Paul Andriesse, AMSTERDAM

1991 Galerie Meert-Rihoux, BRUSSELS
 Gallery Shimada, YAMAGUCHI [catalogue]

1992 Galerie Max Hetzler, COLOGNE
 Museum Haus Lange, KREFELD
 Hirshhorn Museum, WASHINGTON, D.C.

1993 Galleria Monica de Cardenas, MILAN
 Marian Goodman Gallery, NEW YORK
 Galerie Max Hetzler, COLOGNE
 Gallery Shimada, TOKYO
 Hamburger Kunsthalle, HAMBURG [catalogue]
 The Saint Louis Art Museum, ST. LOUIS
 Gallery Senda, HIROSHIMA

1994 Institute of Contemporary Art, BOSTON [catalogue]
 Institute of Contemporary Arts, LONDON
 Marian Goodman Gallery, NEW YORK
 Galerie Meert-Rihoux, BRUSSELS
 Achenbach Kunsthandel, DÜSSELDORF [catalogue]

1995 Art Gallery of Ontario, TORONTO [catalogue]
 Gallery Shimada, TOKYO
 Kunstmuseum Bonn, BONN [catalogue]
 Galerie Max Hetzler, BERLIN
 Marian Goodman Gallery, PARIS

1996 Galleria Monica de Cardenas, MILAN
 Kluuvin Galleria, HELSINKI [catalogue]
 Stadtmuseum, MÜNSTER [catalogue]
 (with Albert Renger-Patzsch)

1997 "Face to face" (with Luo Yongjin)
 Fine Arts Foundation of Beijing,
 International Art Palace, BEIJING [catalogue]

Marian Goodman Gallery, NEW YORK
Galerie Paul Andriesse, AMSTERDAM
Achenbach Kunsthandel, DÜSSELDORF
(with Cindy Sherman)
"Portraits" Sprengel Museum, HANOVER
[catalogue]
"The Berlin Project" (with Klaus vom Bruch)
Galerie Max Hetzler, BERLIN

1998 Galerie Meert-Rihoux, BRUSSELS
Marian Goodman Gallery, PARIS *[catalogue]*
"Still" Carré d'Art, NÎMES *[catalogue]* also:
Stedelijk Museum, AMSTERDAM
Centre national de la photographie, PARIS (1999)
Galerie Rüdiger Schöttle, MUNICH
(with Karin Kneffel & Thomas Schütte)

1999 Gallery Shimada, TOKYO
"The Berlin Project"
(with Klaus vom Bruch)
Kunstverein, HAMBURG
Galleria Monica de Cardenas, MILAN
"New Pictures from Paradise"
Marian Goodman Gallery, NEW YORK
Marian Goodman Gallery, PARIS

2000 Galeri K, OSLO
"Thomas Struth—My Portrait"
National Museum, TOKYO *[catalogue]*
National Museum, KYOTO

2001 Gallery Max Hetzler, BERLIN
Gallery Rüdiger Schöttle, MUNICH
Galerie Meert-Rihoux, BRUSSELS

2002 Dallas Museum of Art, DALLAS
MOCA, Museum of Contemporary Art,
LOS ANGELES

GROUP EXHIBITIONS

1979 *"In Deutschland: Aspekte gegenwärtiger
Dokumentarfotografie in Deutschland"*
Rheinisches Landesmuseum, BONN *[catalogue]*
"Schlaglichter: Junge Kunst im Rheinland"
Rheinisches Landesmuseum, BONN *[catalogue]*

1980 Galerie ERG, BRUSSELS
(with Thomas Schütte & Achim Tiffert)

1981 *"5. Internationale Biennale — Erweiterte Fotografie"*
Wiener Sezession, VIENNA *[catalogue]*
Galerie Rüdiger Schöttle, MUNICH

1982 *"Works by young photographers from Germany"*
Art Galaxy, Barbara Flynn, NEW YORK

1983 *"Ausstellung B"* Lothringer Strasse, MUNICH
"Laputa" Gutenbergstrasse, STUTTGART

1985 New York State University Gallery, NEW YORK
(with Susan Grayson & Joseph Bartscherer)

1986 *"Fotografie und Skulptur"*
Atelierhaus Hansaallee, DÜSSELDORF
"7 Fotografen" Galerie Rüdiger Schöttle, MUNICH
"Standort Düsseldorf '86"
Kunsthalle Düsseldorf, DÜSSELDORF *[catalogue]*

1987 *"Das Ruhrgebiet Heute"*
Museum Folkwang, ESSEN *[catalogue]*
*"Foto / Realismen - Preisträger des Kulturkreises im
Bundesverband der Deutschen Industrie"*
Kunstverein, MUNICH *[catalogue]* also:
Nationalgalerie, BERLIN
Villa Dessauer, BAMBERG
Haus der Industrie, COLOGNE
"Skulptur Projekte Münster'87", MÜNSTER *[catalogue]*

1988 *"Klasse Bernd Becher"*
Galerie Johnen und Schöttle, COLOGNE
"La Razon Revisada / Reason Revised"
Fundacion Caixa de Pensiones,
MADRID & BARCELONA *[catalogue]*
"Fotoarbeiten"
Wolfgang Wittrock Kunsthandel, DÜSSELDORF
Galerie Rüdiger Schöttle, COLOGNE

1989 *"Deconstructing Architecture / Reconstructing History"*
Massimo Audiello Gallery, NEW YORK *[catalogue]*
Marian Goodman Gallery, NEW YORK
Luhring Augustine Gallery, NEW YORK
"Une autre Objectivité - Another Objectivity"
Centre national des arts plastiques, PARIS *[catalogue]*
also: Institute of Contemporary Arts, LONDON
Museo d'Arte Contemporanea Luigi Pecci, PRATO
"Künstlerische Fotografie der 70er und 80er Jahre"
Galerie Ursula Schurr, STUTTGART
"Invisible Cities" Leeds City Art Gallery, LEEDS *[catalogue]*
"Photo-Kunst — Arbeiten aus 150 Jahren"
Staatsgalerie Stuttgart, STUTTGART *[catalogue]*
"Prospect Fotografie" Frankfurter Kunstverein,
FRANKFURT AM MAIN *[catalogue]*

1990 *"Paesaggio"* Galleria Lia Rumma, NAPLES
*"Affinities and Intuition — The Gerald
S. Elliott Collection of Contemporary Art"*
The Art Institute of Chicago, CHICAGO *[catalogue]*
"Aperto '90" Biennale di Venezia, VENICE *[catalogue]*
"Spiel der Spur," Shedhalle, ZÜRICH *[catalogue]*
"de Afstand" Witte de With Center for
Contemporary Art, ROTTERDAM *[catalogue]*
"Images in Transition"
National Museum of Modern Art, KYOTO *[catalogue]*
also: National Museum of Modern Art, TOKYO
"German Photography" The Aldrich Museum of
Contemporary Art, RIDGEFIELD, CT *[catalogue]*
"Weitersehen" Museum Haus Lange, KREFELD *[catalogue]*
"Le Diaphane" Musée des Beaux Arts —
FRAC Nord-Pas de Calais, CALAIS

1991 *"Currents"* Institute of Contemporary Arts, BOSTON
"Typologies" Newport Harbor Art Museum,
NEWPORT, CA *[catalogue]* also:
Akron Art Museum, AKRON
Corcoran Art Gallery, WASHINGTON, D.C.
San Francisco Museum of Art, SAN FRANCISCO
"Lynne Cohen, Thomas Struth, Christopher Williams"
Galerie Samia Saouma, PARIS
"Kunstfonds 10 Jahre"
Kunstverein Bonn, BONN *[catalogue]*
"Le Revanche de l'Image"
Galerie Pierre Huber, GENEVA *[catalogue]*
"This Land" Marian Goodman Gallery, NEW YORK
*"Surgence—Contemporary Creations in
Photography in Germany"*
Comédie de Reims, REIMS *[catalogue]*
Musée Sainte-Croix, POITIERS

Musée des Beaux Arts, RENNES
Musée d'Evreux, EVREUX
"Aus der Distanz" Kunstsammlung Nordrhein Westfalen,
DÜSSELDORF [catalogue]
"Sguarda di Medusa"
Castello di Rivoli, TURIN [catalogue]
"A Dialogue about Recent American and European
Photography"
MOCA, LOS ANGELES [catalogue]
"The Carnegie International 1991" The Carnegie
Museum of Art, PITTSBURGH [catalogue]
"Photography—Individual Positions"
Moderna Galerija, LJUBLJANA [catalogue]
"Doos" Galerie Paul Andriesse, AMSTERDAM

1992 "Photography in Contemporary German Art—
1960 to the Present"
Walker Art Center, MINNEAPOLIS [catalogue]
The Guggenheim Museum, NEW YORK et al.
"C'est pas la fin du monde"
FRAC Bretagne, CHÂTEAUGIRON [catalogue]
Galerie Max Hetzler, COLOGNE
"Ars pro domo" Museum Ludwig, COLOGNE [catalogue]
Marian Goodman Gallery, NEW YORK
"Family Album—Changing Perspective of Family Portrait"
Tokyo Metropolitan Museum of Photography,
TOKYO [catalogue]
"Documenta IX" KASSEL [catalogue]
"Systems of Vision" Ehlers / Caudill Gallery Ltd., CHICAGO
"Mehr als ein Bild"
Sprengel Museum, HANOVER [catalogue]

1993 "Mai de la photo. Genius loci" REIMS [catalogue]
Galerie Max Hetzler, COLOGNE

"The Rome Project" David Winton Bell Gallery,
PROVIDENCE [catalogue]
"Das Bild der Ausstellung"
Heiligenkreuzerhof, VIENNA [catalogue]
"Photographie in der deutschen Gegenwartskunst"
Museum Ludwig, COLOGNE [catalogue] also:
Museum für Gegenwartskunst, BASEL (1994)
"Deutsche Kunstfotografie der 90er Jahre"
Fototage, FRANKFURT AM MAIN [catalogue]
"Distanz und Nähe" Nationalgalerie,
BERLIN [catalogue]
"Diskurse der Bilder" Kunsthistorisches Museum, VIENNA

1994 "German Contemporary Art"
Wako Works of Art, TOKYO
"Exhibited"
Center for Curatorial Studies and Art in
Contemporary Culture, ANNANDALE-ON-HUDSON
[catalogue]
"Die Orte der Kunst"
Sprengel Museum, HANOVER [catalogue]
"The Epic and the Everyday"
The Hayward Gallery, LONDON [catalogue]
"Who's Looking at the Family?"
Barbican Art Gallery, LONDON [catalogue]
"Architektur in der Photographie"
Galerie Wilma Tolksdorf, HAMBURG
"The Label Show: Contemporary Art and the Museum"
Museum of Fine Arts, BOSTON
"La Ville" Centre Georges Pompidou, PARIS [catalogue]
Galerie Samia Saouma, PARIS
"Kunst in Frankfurt – Zeitgenössische Kunst aus
Frankfurter Banken" Jahrhunderthalle Hoechst,
FRANKFURT AM MAIN [catalogue]

"Works from the Collection —
The Institute of Cultural Anxiety"
Institute of Contemporary Arts,
LONDON [catalogue]

1995 "After Art—Rethinking 150 Years of Photography"
Henry Art Gallery, University of Washington,
SEATTLE, WASHINGTON [catalogue] also:
Ansel Adams Center, SAN FRANCISCO
Portland Art Museum, PORTLAND, ME
"RAM — Realität, Anspruch, Medium"
Kunstverein, KARLSRUHE [catalogue] also:
Neues Museum Weserburg, BREMEN
Lindenau-Museum, ALTENBURG
Museum Wiesbaden / Nassauischer Kunstverein
WIESBADEN
"Cityscape" Galleria Monica de Cardenas, MILAN
"Art Museum" Center for Creative Photography—
The University of Arizona,
TUCSON [catalogue]
"People" Galleria Monica de Cardenas, MILAN
"The Reflected Image" Museo Pecci, PRATO
"Standpunkt Stadt" Städtische Galerie, REGENSBURG
[catalogue]
"Portraits" Janice Guy, NEW YORK
"Blumenstücke / Kunststücke"
Kunsthalle Bielefeld, BIELEFELD [catalogue]

1996 "Multiple Exposure—The Group Portrait in Photography"
The Bruce Museum, GREENWICH, CT
[catalogue] also:
Bayly Art Museum, CHARLOTTESVILLE
"Prospect 96" FRANKFURT AM MAIN [catalogue]
"Nobuyoshi Araki, Larry Clark , Thomas Struth,

"Christopher Williams" Kunsthalle Basel, BASEL [catalogue]
"Inside Bankside" South London Gallery, LONDON
"Stadt und Land" (with Simone Nieweg & Thomas Ruff)
Galerie Rüdiger Schöttle, MUNICH
"Recaptured Nature"
Marian Goodman Gallery, NEW YORK
"Stadtansichten. Fotografien 1860–1996"
Otto Nagel Galerie, BERLIN
"Kunststiftung Sabine Schwenk"
Schloss Haigerloch, STUTTGART
"Die zeitgenössische Sammlung des
Westfälischen Kunstvereins"
Westfälischer Kunstverein, MÜNSTER
"Délices & Picturalités"
FRAC Lorraine, METZ [catalogue]
Musée nationale d'histoire & d'art de Luxembourg,
LUXEMBOURG
Galerie de l'Esplanade, Ecole des Beaux-Arts,
Centre National d'Art Contemporain de Grenoble,
GRENOBLE
"Fotografia nell'arte tedesca contemporanea"
Foro Boario, MODENA [catalogue]
"Der fixierte Blick. Deutschland und das Rheinland
im Fokus der Fotografie"
Bayer AG, LEVERKUSEN [catalogue]
"Distanz und Nähe"/"Distance and Proximity"
Kawasaki City Museum, KAWASAKI [catalogue]
Tochigi Prefectural Museum of Fine Arts, TOCHIGI

1997 "Absolute Landscape: Between Illusion and Reality"
Yokohama Museum of Art, YOKOHAMA [catalogue]
"10 Jahre Stiftung Kunsthalle Bern"
Kunsthalle Bern, BERN
"Invisible light" Museum of Modern Art, OXFORD

"Evidence. Photography and Site"
Wexner Center for the Arts, COLUMBUS
"Distanz und Domizil"
Städtische Galerie Rähnitzgasse, DRESDEN
[catalogue]
"NatureVivante" Marian Goodman Gallery, PARIS
"Photographie d'une collection"
Caisse des Dépots et Consignations, PARIS
"Antlitz" Galerie Ropac, SALZBURG [catalogue]
"Positionen künstlerischer Photographie in
Deutschland nach 1945"
Berlinische Galerie im Martin Gropius Bau,
BERLIN [catalogue]
"Museum Studies—Eleven Photographers' Views"
High Museum of Art, ATLANTA
"Kunst unserer Zeit – Zeitgenössische deutsche Kunst
aus Berliner Privatsammlungen",
MOSCOW [catalogue]

1998 Galerie Paul Andriesse, AMSTERDAM
"Art of the 80's" Culturgest, LISBON
"Urban" The Tate Gallery, LIVERPOOL
"The Erotic Sublime"
Galerie Thaddaeus Ropac, SALZBURG
"The 11th Sydney Biennial"
SYDNEY [catalogue]
"Breaking Grounds"
Marian Goodman Gallery, NEW YORK
"Unfinished History"
Walker Art Center, MINNEAPOLIS [catalogue]
"Parkett-Künstlereditionen im Museum Ludwig"
Museum Ludwig, COLOGNE

1999 Galerie Max Hetzler, BERLIN
(with the architect Klaus Theo Brenner)

"The Museum as Muse: Artists reflect"
The Museum of Modern Art, NEW YORK [catalogue]
"Woods" Galleria Monica de Cardenas, MILAN
"Pictures for Pleasure"
Galerie Thaddaeus Ropac, SALZBURG
"Reconstructing Space: Architecture in Recent German
Photograph"
Architectural Association, LONDON [catalogue]
"Art at Work" – 40 Years of Chase Manhattan Bank
Museum of Fine Arts, HOUSTON
"Wohin kein Auge reicht"
Deichtorhallen, HAMBURG [catalogue]
also: Kunsthalle, BASEL (2000)
"Plein Air", Barbara Gladstone Gallery, NEW YORK
"Seeing Time: Selection from Pamela and Richard Kramlich
Coll. of Media Art" MOMA, SAN FRANCISCO
also: ZKM, KARLSRUHE [catalogue] (2000)
"L'Art médecin" Musée Picasso, ANTIBES
"Von Beuys bis Cindy Sherman –
Collection Lothar Schirmer"
Kunsthalle, BREMEN [catalogue]
also: Lenbachhaus, MUNICH
"Presence: Figurative Art at the End of the Century"
The Tate Gallery, LIVERPOOL
"Stadtluft – Der urbane Raum als Medium von Macht"
Kunstverein, HAMBURG
"Apposite Opposites: Photography from the MCA Collection"
Museum of Contemporary Art, CHICAGO
"Das Versprechen der Fotografie – Collection DG Bank"
Kestner Gesellschaft, HANOVER
"Missing Link: Menschen-Bilder in der Fotografie"
Kunstmuseum, BERN [catalogue]
"The Mirror's Edge"
BildMuseet, UMEA [catalogue]

2000 "The Continuity of the Everyday in 20th Century Art"
Castello di Rivoli, Museo d'Arte Contemporanea,
TURIN [catalogue]
"Ansicht Aussicht Einsicht – Konzeptionelle
Architekturfotografie"
Museum Bochum, Kunstsammlung der Ruhr-
Universität, BOCHUM [catalogue]
Galerie für zeitgenössische Kunst, LEIPZIG
Galeria Bunkier Sztuki, KRAKÓW
"Age of Influence: Reflections in the Mirror of American
Culture" MOCA, CHICAGO
"German Photoworks" Wako Works of Art, TOKYO
"Invitation of the City"
Centre Bruxelles 2000, BRUSSELS [catalogue]
"Europeans" Zwirner & Wirth, NEW YORK
"Peking, Shanghai, Shenzhen – Cities of the 21st Century"
Stiftung Bauhaus, DESSAU
Siemens Kulturprogramm, MUNICH [catalogue]
"Around 1984. A Look at Art in the Eighties"
P.S. 1, NEW YORK
"Milano senza confini"
Spazio Oberdan, MILAN [catalogue]
"How you look at it – Photography in the 20th Century"
EXPO 2000 – Sprengel Museum, HANOVER
[catalogue]
also: Städel, FRANKFURT AM MAIN
"5me Biennale de Lyon"
LYON [catalogue]
"Photography Now" Contemporary Arts Center,
NEW ORLEANS [catalogue]
"Architecture Hot and Cold" MoMA, NEW YORK
"Vision and Reality" Louisiana Museum of Modern Art,
HUMLEBÆK, DENMARK

"The Swamp: On the Edge of Eden" Samuel P. Harn
Museum, University of Florida, GAINESVILLE
also: The Cummer Museum of Art & Garden,
JACKSONVILLE (2001)
"AutoWerke"
Deichtorhallen, HAMBURG [catalogue]

2001 "Japan und der Westen"
Paula-Modersohn-Becker Museum,
BREMEN [catalogue]
"Dortmunder forever. Bilder der
Dortmunder Fotosammlung"
Museum für Kunst und Kulturgeschichte,
DORTMUND
"Instant City" Museo Pecci, PRATO

Bibliography

1987 *Unbewußte Orte / Unconscious Places*
 [Ulrich Loock, Ingo Hartmann, Friedrich Meschede]
 Kunsthalle, BERN; Portikus FRANKFURT;
 Westfälisches Landesmuseum, MÜNSTER
 Fruitmarket Gallery, EDINBURGH

1987 *Unconscious Places*
 [Mikio Takata]
 Prefectural Museum of Art, YAMAGUCHI

1987 *Thomas Struth*
 [Jean-François Chevrier]
 Halle Sud, GENEVA

1990 *Thomas Struth — Photographs*
 [Benjamin H. D. Buchloh]
 The Renaissance Society at the University of Chicago,
 CHICAGO

1990 *Thomas Struth — Portraits*
 [Interview: Thomas Struth
 with Benjamin Buchloh]
 Marian Goodman Gallery, NEW YORK

1991 *Thomas Struth: House — Street —*
 Individual — Group [Kyoshi Okutsu]
 Gallery Shimada, YAMAGUCHI

1992 *Thomas Struth — Portraits*
 [Julian Heynen]
 Museum Haus Lange, KREFELD

1993 *Thomas Struth — Museum Photographs [Hans Belting]*
 Schirmer/Mosel, MUNICH

1994 *Thomas Struth — Strangers and Friends*
 [Richard Sennett]
 Schirmer/Mosel, MUNICH
 The MIT Press, CAMBRIDGE, MA

1994 *Thomas Struth — Landschaften [Rupert Pfab]*
 Achenbach Kunsthandel, DÜSSELDORF
 Galerie Max Hetzler, COLOGNE

1995 *Thomas Struth — Straßen*
 [Stefan Gronert, Rupert Pfab, Christoph Schreier]
 Kunstmuseum Bonn, BONN
 Wienand Verlag, COLOGNE

1996 *Thomas Struth — Valokuvia Fotografier [Jan Kaila]*
 Kluuvin Galleria, HELSINKI

1997 *Luo Yongjin, Thomas Struth — Face to Face*
 [Karen Smith, Ingo Hartmann]
 Siemens Kulturprogramm, MUNICH

1997 *Thomas Struth — Portraits*
 [Thomas Weski, Norman Bryson, Benjamin Buchloh]
 Schirmer/Mosel, MUNICH
 Sprengel Museum, HANOVER

2000 *Thomas Struth — My Portrait [Rei Masuda, Kiyoshi Okutsu]*
 Tankosha Publishing Co., Ltd., TOKYO

ALLEN, JENNIFER
"Snapshots of Sensus Communis"
Parachute [Canada]
Nº 79, July/August/September 1995

ALTHOFF, BERNWARD
"Die Kulisse wird zum
Mittelpunkt"
Bonner Rundschau
July 13, 1995

BALFOUR BOWEN, LISA
"Life after Barnes"
Toronto Sun, Sunday Magazine
January 29, 1995

BATAILLON, FRANÇOISE
"Thomas Struth"
Beaux Arts
Nr. 86, January 1991

BATKIN, NORTON
"The Museum Exposed,"
Exhibited
Center for Curatorial
Studies, Annandale–on–Hudson, N.Y.
1994, pp. 4–16

BUTLER, SUSAN
"The Mise-en-scène
of the Everyday"
*Art and Design Profile,
Photography in the Visual Arts*
[London]
Nº 44, 1995, pp. 17–23

BECK, MARTIN
"Das Bild der Ausstellung"
Texte zur Kunst
Nº 11, September 1993, p. 142

BISACCIA, ANTONIO
"Mappe fotografiche per
tracce di sensazioni"
Art Leader Magazine
[Ancona]
Nº 22, March/April 1995

BLASE, CHRISTOPH
"Photos vom Leben –
ganz ohne Menschen"
Artis
February 1988

BLAZWICK, IWONA
"The Whole Struth"
Vogue
May 1994

BOECKER, SUSANNE
"Auf den Spuren der Städte"
Kölner Stadtanzeiger
July 18, 1995

BOLLER, GABRIELE
"Lieux Inconscients"
Art Press
Vol. 122, February 1988

BRÜDERLIN, MARKUS
"Die List des Bildes" [Interview]
Zyma
Nº 3, September/October 1993,
pp. 24–29

BRYSON, NORMAN
"Not Cold, not too Warm:
The Oblique Photography
of Thomas Struth"
Parkett
Nº 50/51, 1997

BURCHARD, HANK
"Eyeing Eyes on Artworks"
Washington Post
May 29, 1992

CANNILLA, GIUSEPPE
"Thomas Struth"
Juliet
Nº 52, April 1991

CHEVRIER, JEAN-FRANÇOIS
"Bernd et Hilla Becher –
Thomas Struth"
Galeries Magazine
December 1988

COLLECTIVE VISION
"Thomas Struth"
*Creating a Contemporary
Art Museum.* Museum of
Contemporary Art, Chicago
1996, p. 114–15

CORK, RICHARD
"Focus on the Way we Look"
The Times [London]
May 1994

DEIRDRE, HANNA
"Photos by Thomas Struth Make
for Powerful AGO Show"
Now Magazine
May 19, 1995

DEMSKI, EVA
"Warten auf unsere Blicke:
Museumsbilder"
*Frankfurter Allgemeine Zeitung/
Magazin*
Issue 736, April 8, 1994

DENK, ANDREAS
"Anthropologische Meßergebnisse"
Bauwelt
N° 33, September 1, 1995, p. 1773

DOSWALD, CHRISTOPH
"Thomas Struth"
Kunstforum
April 1988

DURAND, RÉGIS
"Thomas Struth. Realism
and Recollection"
Art Press [Paris]
N° 213, May 1996, pp. 28–33

DURDEN, MARK
"Strangers and Friends.
Thomas Struth at the ICA"
Creative Camera
June/July 1994, pp. 44–5

DURDEN, MARK
"Absorption and
Thomas Struth's Photography"
Camera Austria International
N° 55,1996, pp. 67–68

EDWARDS, TAMALA M./
MITCHELL, EMILY
"Bearing with Reality. Thomas
Struth. Strangers and Friends"
Time
March 13, 1995

ENGELHARD, GÜNTHER
"Du sollst allein sein
mit Deinem Motiv!"
Rheinischer Merkur
July 21, 1995

FRÄMCKE, RICARDA
"Wer schaut hier eigentlich wen an?"
Hamburger Abendblatt,
November 19, 1993

FREY, PATRICK
"Genau konstruierte
Gesichter, geräumte Leere"
Wolkenkratzer
January 1988

FULFORD, ROBERT
"Photography and its Discontents"
Canadian Art
N° 1, Spring 1995, pp. 55–65

GIBSON, ERIC
"Struth Photographs:
Art in Beholder's eye"
The Washington Post
May 28, 1992

GIRLING, OLIVER
"An Objective Photographer"
Eye Weekly Magazine
March 30, 1995, p. 39

GISBOURNE, MARK
"Struth. Thomas Struth
discusses silence, society and
the self with Mark Gisbourne"
Art Monthly
N° 176, May 1994, pp. 3–7

GOODING, MEL
"Alan Johnston,
Thomas Struth,
Edinburgh International"
Art Monthly
N° 113, February 1988

GOTTLIEB, KATRIEN
"Kijken naar je eigen rug"
Het Parol
February 6, 1990

GRASS, MATTHIAS
"Begegnung mit
dem Fremden"
Rheinische Post
June 17, 1995

GRAW, ISABELLE
"Ortskunde –
ein Interview
mit Thomas Struth"
Artis
December 1989

GROSS, ROLAND
"Straßen als Foto-Objekte"
Ruhr-Nachrichten
September 14, 1995

GROSS, ROLAND
"Alltag ohne Menschen"
Darmstädter Echo
August 31, 1995

GROUD, CATHERINE
"Thomas Struth –
Halle Sud"
Arte Factum
September 1989

HAGEN, CHARLES
"A German Photographer
at Marian Goodman Gallery"
New York Times
March 12, 1993

HAGEN, CHARLES
Thomas Struth, "A Portfolio",
A Publication of Bard College,
Annandale
Winter 1994/95

HALL, JAMES:
"Fill the void"
The Guardian
May 16, 1994

HAPGOOD, SUSAN
"Thomas Struth at
Marian Goodman"
Art in America
January 1991

HARTOG JAGER,
HANS DEN
"De huppelnde straten
van Thomas Struth"
NRC Handelsblad
August 7, 1995

HEGEMER, TILLA
"Augen-Blicke unterwegs"
Kabinett
March 1995

HENRY, CLARE
"Works of Art that climb
a staircase"
Glasgow Herald
December 11, 1987

HERBSTREUTH, PETER
"Kirche imHalbschatten.Thomas
Struth in der Galerie Max Hetzler"
Der Tagesspiegel
November 18, 1995

HERMES, MANFRED
"Thomas Struth.
Galerie Max Hetzler"
Artscribe
Summer 1989

HIXSON, KATHRYN
"Thomas Struth – Hoping
to transcend the photograph's
representational function"
Flash Art
July 1990

HOFFMANN, JUSTIN
"Thomas Struth –
Galerie Rüdiger Schöttle"
Artforum
April 1989

HOLERT, TOM
"Das geduldige Auge"
Vogue
December 1993, pp.102–4

HUME, CHRISTOPHER
"The Cleansing Lens
of Thomas Struth"
The Toronto Star
January 26, 1995

INGENPAHS, HEINZ J.
"Personen in einer wesenlosen Zeit"
Westdeutsche Zeitung
February 1992

IWAO, MATSUYAMA
"The Enduring Power of
Confronting Unconsciousness"
Kula Intercity Photo Magazine
Winter 1980

JANUSZCAK, WALDEMAR
"Struth to Tell"
The Sunday Times
May 1, 1994

JANZEN, THOMAS
"Leere und gestaltete
Wahrnehmung"
Frankfurter Rundschau
August 24, 1995

"New Directions of Photography
and Fine Art/ Thomas Struth"
Bijutsu Techno
Vol. 43, September 1991

KAILA, JAN, & KUISMA,
KRISTIINA
"Tiedostamattoman
Nekeminen"
Valokuve
March 1993

KOENIG, THILO
"Eine fragwürdige Liebe"
Frankfurter Allgemeine Zeitung
December 17, 1993

KRUSE, CHRISTIANE
"Eigenartige
Sonntagmorgenstimmung"
Süddeutsche Zeitung
August 17, 1995

KUSPIT, DONALD
"Thomas Struth –
Marian Goodman"
Artforum
December 1990

KUSPIT, DONALD
"Sizing Art Up (and Down)"
The Quality Issue
The Magazine of Contemporary Art
N° 31, Fall 1991

KUSPIT, DONALD
"Thomas Struth – Marian Goodman"
Artforum
May 1993

LEBRERO, JOSÉ
"La Escuela de Düsseldorf"
Lapiz
N° 86, May 1990

LETTMANN, ACHIM
"Strenge Städtebilder"
Westfälischer Anzeiger
August 17, 1995

LINGWOOD, JAMES
"Open Vision"
Parkett
N° 50/51, 1997

LOOK, ULRICH
"Thomas Struth"
Creative Camera
May 1988

LOOK, ULRICH
"Unbewußte Orte"
Parkett
March 1990

LUX, HARM
"Thomas Struth. Unconscious places"
Kunsthalle Bern
C Laiwan
March 1988

MATZ, REINHARD
"Ängstliche Perspektive"
Die Tageszeitung
July 24, 1995

MAYS, JOHN BENTLEY
"Struth's Photos Alter
our Focus on Urban Spaces"
The Globe and Mail
January 21, 1995

MEAD, ANDREW
"Focusing on the Familiar
but Unseen"
The Architects' Journal [London]
May 18, 1994

MEDICUS, THOMAS
"Starrheit von Mensch und Ding.
Distanz und Nähe: Fotografien in
der Neuen Nationalgalerie"
Der Tagesspiegel
September 26, 1993, p. 22

MEISTER, HELGA
"Dokumentarfotografie"
Art
October 1989

MEISTER, HELGA
"Im Gespräch mit der Natur"
Photos von Thomas Struth
Westdeutsche Zeitung
August 30, 1994

MESSLER, NORBERT
"Thomas Struth.
Galerie Max Hetzler"
Artforum International
November 1993, p. 120

MILLAR, JEREMY
"When You're Strange"
Frieze
Issue 15, March/April 1994,
pp. 30–35

MORIN, FRANÇOIS YVES
"Le Regard Indifférent"
Halle Sud Magazine
N° 21, 1989

MÜLLER, BERTRAM
"Hinter die Fassaden.
Straßen–Fotografien
von Thomas Struth in Bonn"
Rheinische Post
July 17, 1995

OKUTSU, KIYOSHI
"Photography as Tautegory"
Parkett
N° 50/51, 1997

OTT, PAUL
"Unbewußte Orte"
Die Wochenzeitung
October 16, 1987

POLZER, BRITA
"Thomas Struth fotografiert
für das Lindbergspital
in Winterthur"
Kunstbulletin
September 1993, pp. 12–15

REUST, HANS RUDOLF
"Backdrop"
Artscribe
March 1988

ROEGIERS, PATRICK
"Un bon élève"
Le Monde
November 6, 1990

ROSENZWEIG, PHYLLIS
"Thomas Struth –
Museum Photographs"
Brochure of exhibition at the
Hirshhorn Museum,
Washington, D.C.
May 1992

SAINT LOUIS ART MUSEUM
"Currents 56:
Thomas Struth"
*The Saint Louis Art
Museum Magazine*
N° 11/12, 1993

SALTZ, JERRY
"What is the Reason for
your Visit to this Museum?"
Arts Magazine
January 1991

SCHJELDAL, PETER
"God's Struth"
Village Voice
February 1993

SCHJELDAL, PETER
"Epiphany"
Parkett
N° 50/51, 1997

SCHMID, KARL-HEINZ
"Kühl, karg und immer in Serie"
Art
November 1987

SCHUMANN, ULRICH-
MAXIMILIAN
"Platz da für die Straße!"
Tages-Anzeiger
September 4, 1995

SCHWABSKY, BARRY
"Thomas Struth"
Arts Magazine
December 1990

SHERLOCK, MAUREEN P.
"Thomas Struth"
Tema Celeste
N° 27/28, November 1990

SHERLOCK, MAUREEN P.
"Thomas Struth",
Tema Celeste
N° 30, March 1991

SPIEGL, ANDREAS
"Thomas Struth –
Fragen nach dem Blick"
Eikon
N° 5, 1993

STAHEL, URS
"Architektur ist unsere
dritte Haut. Architektur-
fotografien von Thomas Struth in
der Kunsthalle Bern"
Die Weltwoche
October 22, 1987

STEINER, MARY ANN
"Photographs"
*The Saint Louis Art Museum
Annual Report*
November 1992, p. 24

STORCH, CHARLES
"Not all Art Institute
Visitors Want to Pore over new
'Rainy Day'"
Chicago Tribune
September 14, 1995

STRUTH, THOMAS
"Photographs from East Germany"
October
N° 64, Spring 1993, pp. 34–56

THIELE, CARMELA
"Struth's Straßen:
Die exotischen Seiten
der Normalität"
Bonner Generalanzeiger
July 12, 1995

TEGENBOSCH, PIETJE
"Museum Photographs"
de Volkskrant
November 17, 1990

TSCHECHNE, MARTIN
"Alle meine Sachen
sind Portraits"
Art
September 1993, pp. 70–76

UIMONEN, ANU
"Maalari valokuvaajana"
Helsingin Sanomat
August 22, 1996

URSPRUNG, PHILIP
"Thomas Struth in Genf"
Nike
N° 29, 1989

VERZOTTI, GIORGIO
"Thomas Struth. Photography
of Abstraction"
Art + Text
Nº 47, January 1994

VINCI, JOHN
"Exhibiting Spaces"
Forum International
Nº 13, May–August 1992, pp. 36–42

WAGNER, THOMAS
"Vor der Kamera sind
alle Städte gleich"
Frankfurter Allgemeine Zeitung
August 8, 1995

WELZENBACH, MICHAEL
"The Frame of Reference"
The Washington Post
June 10, 1992

WINKEL, CAMIEL VAN
"Het overshot van utopieen.
De Düsseldorfse school/
Vestiges of Utopia.
The Düsseldorf School"
Archis
Nº 10, 1995, pp. 66–80

WINZEN, MATTHIAS
"Krefeld: Thomas Struth
im Museum Haus Lange"
Kunst-Bulletin
Nº 4, April 1992

WOLF, HERTA
"Zu Skulpturen geronnene
Architekturen"
Camera Austria
February 1990

WYROLL, REGINA
"Revidierte Vernunft?"
Artscribe
January 1989

ZELLWEGER, HARRY
"Straßen und Städte
ohne Menschen"
Neue Zürcher Nachrichten
October 24, 1987

"Out of the archives-referring
to architecture"
*MAMA. Magasin for
modern architektur*
Nº 12, 1995, pp. 29–45

Lenders

Helge Achenbach, DÜSSELDORF | Collection Paul Andriesse, AMSTERDAM | Hans Böhning, COLOGNE | Museum Boijmans van Beuningen, ROTTERDAM | Carré d'Art – Musée d'art contemporain, NÎMES | Deutsche Bank AG, FRANKFURT AM MAIN | Hannah Erdrich-Hartmann, DÜSSELDORF | Dorothee Fischer, DÜSSELDORF | Fonds National d'Art Contemporain, PUTEAUX | Marian Goodman, PARIS, NEW YORK | Ingo Hartmann, DÜSSELDORF Raphael Hartmann, DÜSSELDORF | Galerie Max Hetzler, BERLIN | Candida Höfer, COLOGNE | Museum Kurhaus, KLEVE | Galerie Laage-Salomon, PARIS | Collection Malerba, MILAN | Galerie Meert Rihoux, BRUSSELS | Christian et Cherise Moueix, LIBOURNE | Collection Olbricht, ESSEN | Gerhard Richter, COLOGNE Galerie Schönewald und Beuse, KREFELD | Stedelijk Museum, AMSTERDAM | Südwest LB, STUTTGART/ MANNHEIM | Angelika Taschen, COLOGNE

First published on the occasion of the exhibition Thomas Struth, organized by Carré d'Art—Musée d'Art Contemporain, Nîmes, the Stedelijk Museum, Amsterdam, and the Centre National de la Photographie, Paris.

At Carré d'Art the exhibition was made possible with kind help of the city of Nîmes. It has received support from the Ministère de la Culture et de la Communication – Direction des Affaires Culturelles du Languedoc-Roussillon.

General curator
GUY TOSATTO, ASSISTED BY BARBARA SCHRÖDER

Curator in Amsterdam
HRIPSIMÉ VISSER

Curator in Paris
RÉGIS DURAND

Catalogue
THOMAS STRUTH, JAMES LINGWOOD

Design
LAMBERT UND LAMBERT, DÜSSELDORF

French-English translations
CHARLES PENWARDEN

Photoengraving
NOVA CONCEPT, BERLIN

Printer
EBS, VERONA

© *1998 by*
THOMAS STRUTH AND THE AUTHORS

A SCHIRMER/MOSEL PRODUCTION

First published in the United States of America in 2001 by
The Monacelli Press
10 East 92nd Street, New York, New York 10128

Library of Congress Control Number: 2001087946
ISBN: 1-58093-094-8